W9-AOV-465

IMAGES
of America

HIGHLANDTOWN

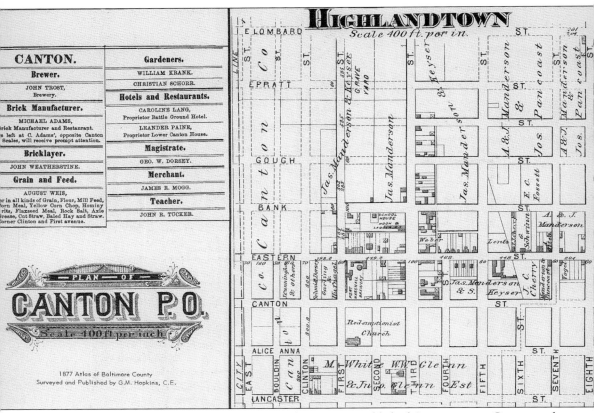

The name Snake Hill was history by the time this map was published. Incorporating Canton with Highland Town, it comes from the 1877 Atlas of Baltimore County. (Courtesy Dundalk–Patapsco Neck Historical Society Museum.)

ON THE COVER: This 1919 photograph depicts the Grand Café at 519 South Third (Conkling) Street. Joseph M. Regan Sr., the owner, is the third man from the right. That's the Grand Theatre at the left. Between the buildings, a door with a sign reading "Stage Entrance" led to a narrow passageway dividing the theatre from the café. Regan reportedly rented his upstairs rooms to actors appearing at the theatre, which at the time featured live Vaudeville acts. Prohibition shut down the Grand Café in 1920. (Courtesy Patrick Shannon Regan.)

IMAGES
of America

HIGHLANDTOWN

Gary Helton

ARCADIA
PUBLISHING

Published by Arcadia Publishing
Charleston SC, Chicago IL, Portsmouth NH, San Francisco CA

Printed in the United States of America

Library of Congress Catalog Card Number: 2006928118

For all general information contact Arcadia Publishing at:
Telephone 843-853-2070
Fax 843-853-0044
E-mail sales@arcadiapublishing.com
For customer service and orders:
Toll-Free 1-888-313-2665

Visit us on the Internet at www.arcadiapublishing.com

CONTENTS

ACKNOWLEDGMENTS

I sincerely wish to thank everyone who encouraged and supported this project. Between February and July 2006, I visited more than 40 current and former Highlandtown residents and merchants. The courtesies I was shown cannot be described. Without exception, total strangers opened their homes and offices, their scrapbooks and memories, and made me feel as if I was an old friend. That doesn't happen much anymore. Early on, I decided I would try to reflect this generosity through the photographs I would ultimately choose to be in this book. It is impossible, given the space provided, to acknowledge everyone who contributed pictures, just as it was impossible to use everyone's photographs. Out of nearly 600, only about 200 made the cut. There are, however, some prominent individuals and organizations that were particularly helpful during the creation of this book, and they deserve special mention.

Jacqui Watts and Mary Helen Sprecher of the *Baltimore Guide* did an outstanding job getting the word out to the community, as did Wayne Laufert and Marge Neal of the *Dundalk Eagle* and *What's Happening* magazine. Jeff Korman and his staff at the Maryland Department of the Enoch Pratt Free Library in Baltimore were helpful and courteous during my many visits, as were Jerry Kelley and all the volunteers at the Baltimore Streetcar Museum. Bill Miller of the Patterson High School Alumni Association also aggressively got the word out and hooked me up with a lot of former Clippers and their photographs. I can't say enough about Jean Jomidad, who made available to me the photograph archives of St. Elizabeth Church on behalf of Rev. Robert Sisk, Third Order Regular (T.O.R.) of St. Francis of Assisi.

I'm also grateful for the generosity of Mike Dunleavy in the Philadelphia Public Relations office of Crown Holdings (formerly Crown Cork and Seal), along with Phyllis Stock Yakim and Marco Cocito-Monoc, Ph.D., of the Southeast Community Development Corporation.

John Rockstroh shared some wonderful Highlandtown photographs taken by his father (regrettably many more were lost in a fire), and Ed Dobbins provided a wealth of pictures and information on the Grand Theatre. Joe Bolewicki took time out on a rainy April day to tell me stories and provide more names and addresses, and Mike Yeager Jr. was extremely patient while we played phone tag for more than a month.

As he did with my first book, my son, Jason Helton, provided computer support (although not nearly as much this time—see son, I can be taught), and my wife, Mary Ellen, took a ton of telephone messages while tolerating "stuff" all over her dining room table.

To everyone else, those who contributed photographs and memories and made me feel welcome in their home, thank you very much. This book is for you, and it was a privilege to compile it. It is also in memory of those Highlandtowners that have left us, especially Anna and Frank Hulseman, whose unconditional love I can never repay.

—Gary Helton
Bel Air, Maryland
July 26, 2006

INTRODUCTION

Metaphorically Highlandtown is a bountiful garden that has borne fruit for more than a century. Its seeds have been carried about by the winds of time and change, but the original roots run strong and deep. They grow not from the earth, but from family and faith—Old World traditions transplanted from Germany, Poland, Ireland, Italy, Greece, and Wales. Though generations removed, remnants of these distinct and original cultures remain. They're what keep people here and draw others back.

Long before the first white marble step appeared, the area now known as Highlandtown was part of the largely undeveloped and hilly estate of Capt. John O'Donnell, the first Baltimore merchant to trade with China. Established in 1785, he called his estate Canton in honor of the Chinese city. By 1796, Canton had grown from 11 to nearly 2,000 acres. Its waterfront location facilitated the development of industry, like Maj. David Stodder's shipyard on Harris Creek, which, in 1797, produced the USS *Constellation*, first ship of the U.S. Navy. The Canton Iron Works fabricated materials for Peter Cooper's steam locomotive *Tom Thumb* in 1829. During the Civil War, Canton's Abbott Mills would make the armor plating for the Union's ironclad ship *Monitor*.

As Canton's industry and labor force grew, so did its need for housing. With the Patapsco River to the south and Baltimore to the west, logic dictated northeasterly expansion onto the property of the Canton Company, established in 1828 by Capt. John O'Donnell's son, Columbus O'Donnell, with inventor/financier Peter Cooper and wealthy businessman William Patterson. By 1850, the former O'Donnell property boasted two churches, a public school, and over 100 residential dwellings. Fort Marshall was established in 1862 on Snake Hill, at what is now Highland and Foster Avenues—the present-day site of Sacred Heart of Jesus Roman Catholic Church.

In short measure, industry began to fill in the area between Snake Hill and what is now Patterson Park. Breweries and slaughterhouses came first. In 1855, the three Schluderberg brothers, Conrad, William, and George, established a butcher shop at Third (Conkling) and Bank Streets; it would in time become Esskay. George Weissner opened Fort Marshall Brewery in 1869 at what are now Highland and Eastern Avenues. Weissner's brewery would soon include a beer garden, dance pavilion, picnic ground, and bowling alley. Meanwhile, there was no shortage of cornfields, dairy farms, woods, and pastureland. This was, after all, 19th-century Baltimore County.

By the 1870s, Snake Hill had its own policeman, a fire department, additional breweries, several more churches, saloons galore, and a new name. Reacting to citizen demands, it became Highland Town. By 1881, Canton and Highland Town had a combined population of nearly 3,000. Responding to a failed attempt in 1888 by the city of Baltimore to expand a mile eastward, residents of Canton and Highland Town petitioned state lawmakers in 1892 to allow the two communities to consolidate into one, separate from both the city and Baltimore County. The measure was defeated, but Baltimore City's leaders wouldn't forget this gesture of defiance.

A building boom occurred in the early 20th century. By 1915, rows of houses completely connected Canton with Highland Town. Streetcars from the United Railways and Electric Company lumbered up and down thoroughfares of dirt or cobblestone. William Painter, who invented the cork bottle

cap, established Crown Cork and Seal. Theaters like the Arrow, Eagle, and Grand started to appear, while along Eastern Avenue, a major commercial district was taking shape. Local artist William Oktavec had begun painting scenes on window screens. To the east, Bay View Asylum treated the insane and would later evolve into a general hospital. Established as an almshouse in 1776, it was supported by both Baltimore City and County and moved twice before relocating to Eastern Avenue after the Civil War. At that point, the city assumed all responsibilities, despite the fact that the asylum was located in Baltimore County. But that was about to change.

As the second decade of the new century was drawing to a close, the city of Baltimore needed more revenue. City leaders complained that Baltimore's busy harbor fell within three separate political jurisdictions—Baltimore City, Baltimore County, and Anne Arundel County—with neither county supporting the port financially. Further, the city argued that it needed additional land to provide better fire and police protection plus take advantage of future business opportunities. Increased port traffic would translate into more dollars for the state, and since the city was already providing over half the revenue spent in Annapolis, the case for annexation seemed a certainty. Nevertheless, Baltimore mayor James H. Preston included $50,000 in the budget to cover advertising and "legislative expenses." On March 29, 1918, the Maryland General Assembly voted to take 46.5 square miles from Baltimore County and 5.4 square miles from Anne Arundel. This would move the city/county line from the middle of East Avenue to a point 2.4 miles east. Despite bitter opposition from residents, Highland Town was annexed by Baltimore City on January 1, 1919. To add insult to injury, city fathers elected to change its spelling to Highlandtown, to discourage any thought that the community was independent of Baltimore. Many residents responded sarcastically, referring to Baltimore thereafter as "West Highland Town."

Except for the Great Depression, the 1920s through the 1950s were generally prosperous times for Highlandtown. The city's sewer system replaced backyard "earth closets," while along the Avenue, long-standing restaurants and retailers like Haussner's, Epstein's, White Coffee Pot, Arundel Ice Cream, Yeager's, G&A Restaurant, and Read's Drug Stores took up residence. Read's and the Coffee Pot in fact had two locations, each within a few blocks of the other. Along residential streets, it seemed there was a butcher, baker, barber, or grocer on every corner, along with the occasional bar. The "I Am An American Day" parade was held annually. Meanwhile, Patterson Park was alive with seemingly non-stop soccer games, tennis, dances, baseball, swimming, boating, and more. The Avenue's streetcars were replaced by more maneuverable electric busses called "trackless trolleys," and an underpass was built along Eastern Avenue near Greektown to eliminate freight-train crossings. Duckpin bowling lanes proliferated, while Luby peddled Chevrolets from a showroom at Eastern Avenue and Eaton Street. Wieland's offered the latest home furnishings, and Louis J. Smith's Sporting Goods attracted every sandlot and high school athlete. Kids played "curb ball" in the street with a high-bouncing rubber ball called a "Pinky" bought at the corner variety store, pausing only to accommodate a passing "machine," as old folks called cars. Teenagers held court at confectionaries over sundaes served in stainless steel dishes. Depending upon which street you lived on, the air was ripe with the smell of oil from the Esso refinery, hops and yeast from Gunther's and National breweries, car and bus exhausts from the Avenue, or the kitchens of thousands of moms laboring over the next family meal. In the alley, "The Umbrella Man" rang a school bell to alert housewives that he was available to mend bumbershoots or sharpen kitchen knives. Plant horns and train and tugboat whistles sounded. Dogs barked. All around, church bells tolled each passing hour—hours lost now but for fading memories and photographs.

One

FROM SNAKE HILL TO HIGHLANDTOWN

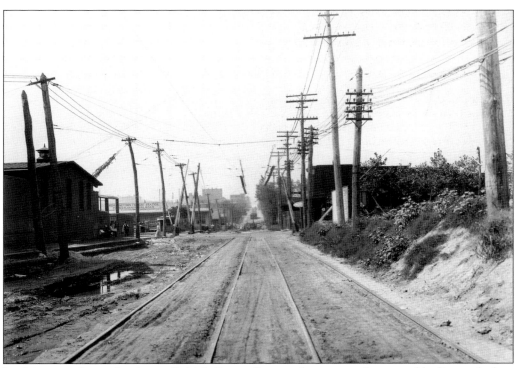

Looking west from what is now Lehigh Street, Eastern Avenue was just a muddy dirt road when this photograph was taken on September 17, 1915. The tall building in the background just left of center is the Grand Theatre, which opened the year before. (Courtesy the Maryland Rail Heritage Library of the Baltimore Streetcar Museum, Inc./Baltimore Chapter National Railroad Historical Society [NRHS], Inc.)

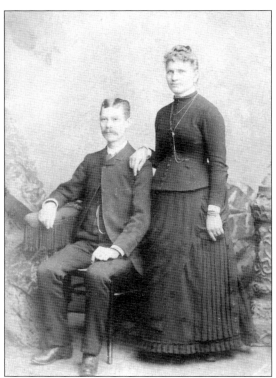

Mr. and Mrs. Andrew Vogler were German immigrants that lived at 3919 Hudson Street. Mr. Vogler ran a tobacco store in Fells Point, near the present-day corner of Anne and Aliceanne Streets. (Courtesy Florence Gundlach.)

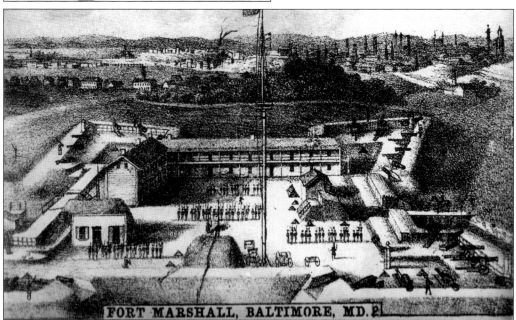

FORT MARSHALL, BALTIMORE, MD.

This lithograph depicts Fort Marshall, a Civil War fortress that once stood at the area's highest point, the current location of Sacred Heart of Jesus Church. It was garrisoned by the 5th New York Heavy Artillery from May 1862 to April 1864 and later by the 11th Indiana and the 1st U.S. Veterans Volunteers. (Courtesy Enoch Pratt Free Library.)

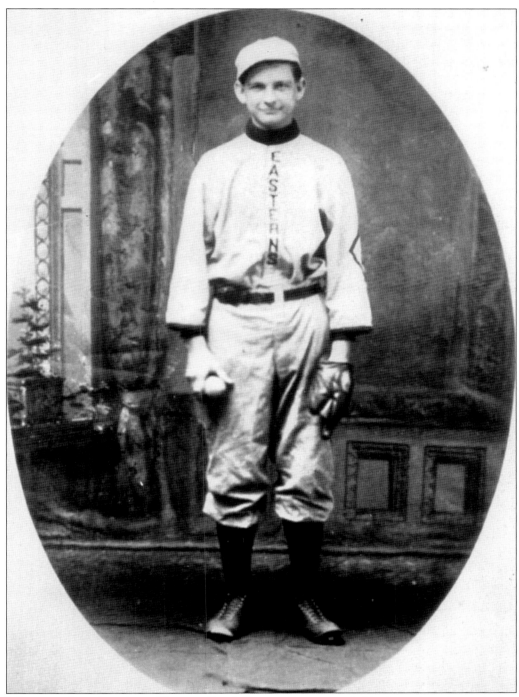

Like most American boys, Herman Frank Ramsel Sr. was probably dreaming about playing baseball in the big leagues when he posed in the uniform of the Easterns around 1910. Those old wool uniforms were hot and heavy, and they only got heavier once they became saturated with perspiration. (Courtesy Elizabeth Adams.)

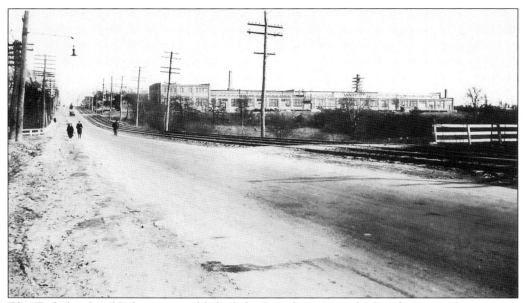

The Turk family of Baltimore established the Porcelain Enamel Manufacturing Corporation (Pemco) at 5601 Eastern Avenue in 1911. Nearly a century later, Pemco International has facilities around the globe in nine countries. The Eastern Avenue plant remains in operation today and looks relatively the same as it did when this picture was taken in the 1920s. (Courtesy John Rockstroh.)

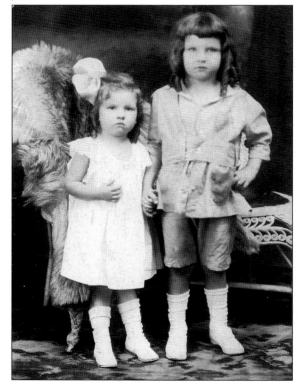

Sister and brother Ruth and William Eaton of the 100 block of South Bouldin Street posed for this portrait around 1917. Long curls were still popular on very young children of both sexes a century ago. (Courtesy Betty Lane.)

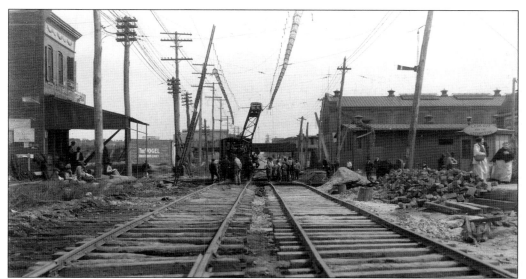

This was the view along Eastern Avenue looking east from Eleventh (Kresson) Street on September 27, 1915. A few workmen labor on streetcar tracks where they intersect with the Northern Central Railroad. Others enjoy a break on the porch of Stabele's Café at the left. (Courtesy the Maryland Rail Heritage Library of the Baltimore Streetcar Museum, Inc./Baltimore Chapter NRHS, Inc.)

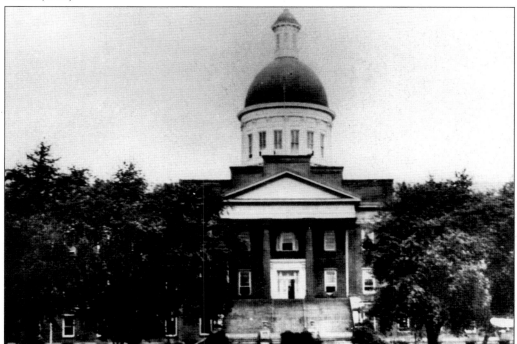

Bay View Asylum's distinctive dome made it appear to be a hotel to many passing travelers. This photograph was taken in 1913, 47 years after the hospital moved to Eastern Avenue and 12 years before it became Baltimore City Hospitals. (Courtesy Dundalk–Patapsco Neck Historical Society Museum.)

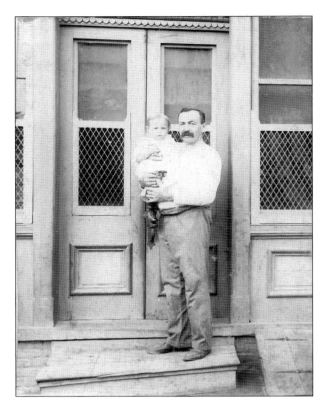

This 1898 photograph depicts Henry Faulstich (1856–1932) with daughter Carrie in the doorway of the family bakery and home at 706 South First Street (Highland Avenue). A native of Melperts, Germany, Henry and his brothers John, Julius, and Nicholas established Faulstich Bakery at Castle and Orleans Streets in 1880 but moved to Highland Town in 1894. (Courtesy M. Rita Hubbel.)

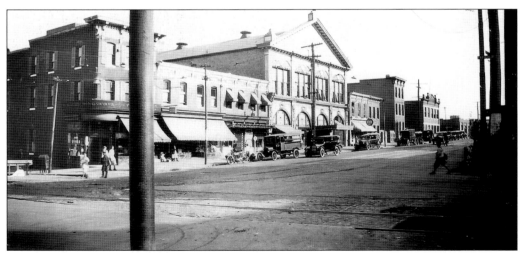

This was the corner of Eastern Avenue and Third (Conkling) Street on the afternoon of October 7, 1922. At the left on the southeast corner is Wager's Pharmacy, which was also the area post office. The large structure in the center is the Grand Theatre. Next door, the former Grand Café (cover) has become a bakery thanks to Prohibition. Farther down the block at Fleet Street, Sellmayer's has opened a banquet facility at the site of their old stockyard. (Courtesy John Rockstroh.)

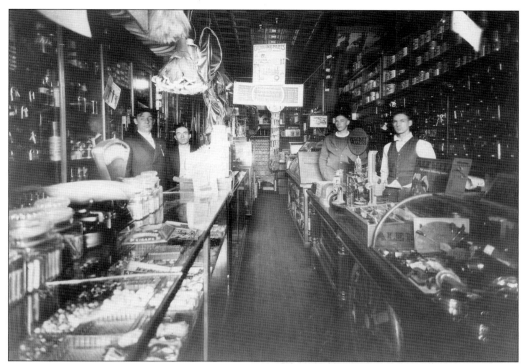

The shelves and display cases at Kitz Motors at 3239 East Baltimore Street were full but in good order when this shot was taken in January 1926. Over the years, it was both an auto parts store and bicycle shop. Founder John Kitz (1883–1963) is at the left. At the far right is Kenneth Knight. The other men are unidentified. (Courtesy John and Frances Kitz.)

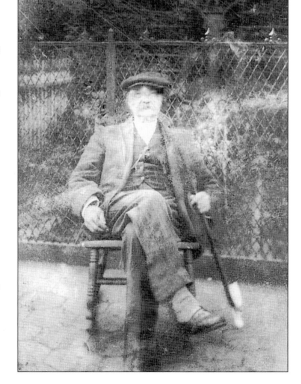

Leopold Ramsel was born in Germany in 1844. He's seen here in the early 1900s at the front yard of his home, 3725 Eastern Avenue. Located near the present-day corner of Eaton Street, the building remained a private residence for many more years. (Courtesy Elizabeth Adams.)

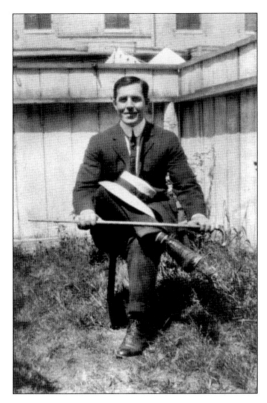

Bartholomew Augustus Lane (1885–1941) was born in Pennsylvania of Irish parents. He married Waneita Cunningham in 1912 and settled in the 100 block of South Bouldin Street. There, in a small row house, the couple raised 12 children. Always a sharp dresser, he is seen here in his yard in the 1920s. The cane was just for show. (Courtesy Betty Lane.)

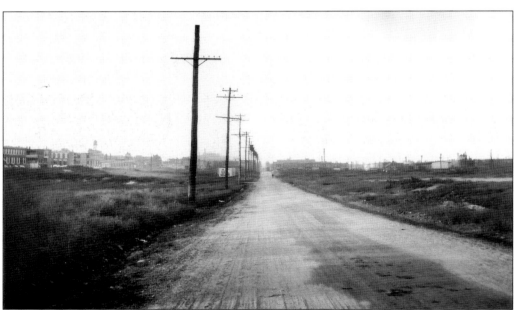

This is South Eighth (Haven) Street looking north toward Eastern Avenue. It was still a dirt road when this shot was taken on October 1, 1922, and industry along the railroad tracks to the right had not yet set up shop. (Courtesy John Rockstroh.)

Annie, John Henry, and Dora Vogler (pictured from left to right) got all dressed up for this early-20th-century portrait. The Voglers were of German descent and lived on Hudson Street in the area now referred to as Brewer's Hill. (Courtesy Florence Gundlach.)

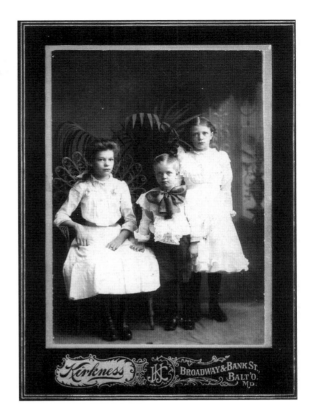

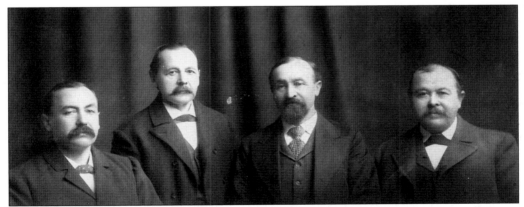

This formal shot of the Faulstich brothers was probably taken in the 1880s. From left to right are Henry, John, Julius, and Nicholas. Although the family bakery on Highland Avenue closed years ago, descendants of the Faulstich brothers still make their homes in Highlandtown and Canton. (Courtesy M. Rita Hubbel.)

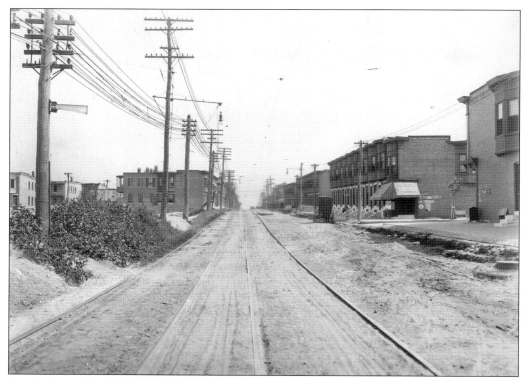

It is hard to imagine that busy Eastern Avenue was once a dirt road, but such was the case in 1915. A horse-drawn delivery wagon sits before a bakery at present-day Macon Street looking east. So many residents were employed by Crown Cork and Seal that neighbors often referred to the area as "Crown City." (Courtesy the Maryland Rail Heritage Library of the Baltimore Streetcar Museum, Inc./Baltimore Chapter NRHS, Inc.)

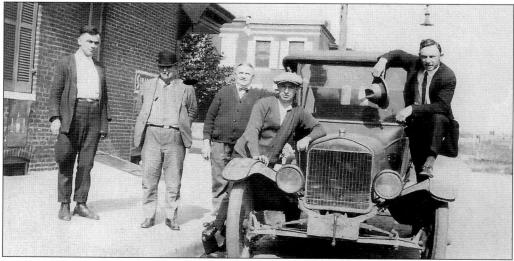

Locals called the intersection of Hudson and Grundy (Seventh) Streets "Scharfe's Corner." Scharfe's Grocery Store is to the left of the vintage car and unidentified men in this October 19, 1924 shot. (Courtesy John Rockstroh.)

Before the city sewer system was constructed, heavy rains often meant flooding in low-lying areas, like this section between Haven (Eighth) and Grundy (Seventh) Streets in the 1920s. The young man is not identified. (Courtesy John Rockstroh.)

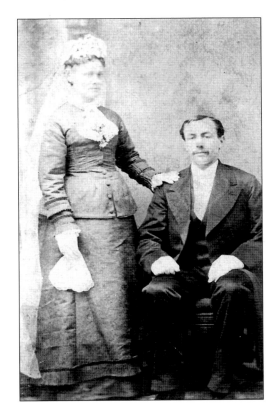

Henry Faulstich and Katherina Elsesser were married at St. Michael's in the late 1870s. They sat for this formal photograph after the ceremony. Life thereafter revolved around the family bakery and their children. (Courtesy M. Rita Hubbel.)

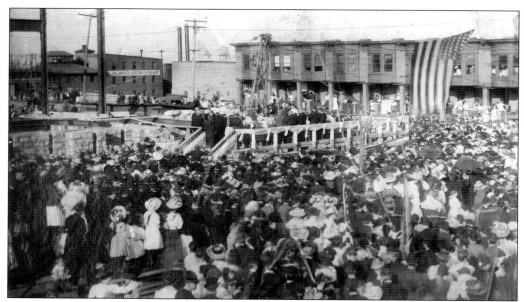

Hundreds gathered on October 4, 1908, for the cornerstone ceremony at the new Sacred Heart of Jesus Church at Foster Avenue and Third (Conkling) Street. Built on the site of Fort Marshall, the original 1873 parish was at First Street (Highland Avenue) and Foster Avenue. Sellmayer's slaughterhouse can be seen in the background at Fleet and Third Streets. The church built in 1908 is located one block east. (Courtesy Elizabeth Adams.)

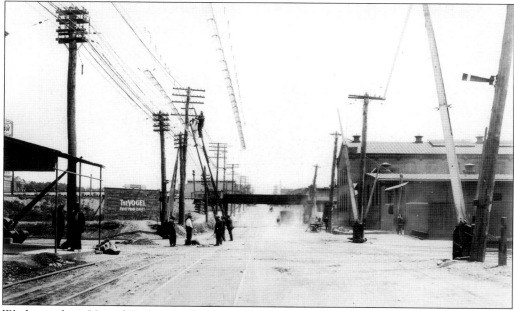

Workmen from United Railway and Electric Company can be seen in this photograph working on the streetcar catenary lines along Eastern Avenue at Eleventh (Kresson) Street. This shot looking east was taken May 10, 1915. Twenty years later, the Eastern Avenue underpass would be built here. (Courtesy the Maryland Rail Heritage Library of the Baltimore Streetcar Museum, Inc./Baltimore Chapter NRHS, Inc.)

Mueller Bros., 160 S. Broadway

This 1896 portrait features Mary P. (Minnie) Sommers, who would grow up to marry into the Faulstich family and work at the family bakery on First Street until her death in the 1950s. (Courtesy M. Rita Hubbel.)

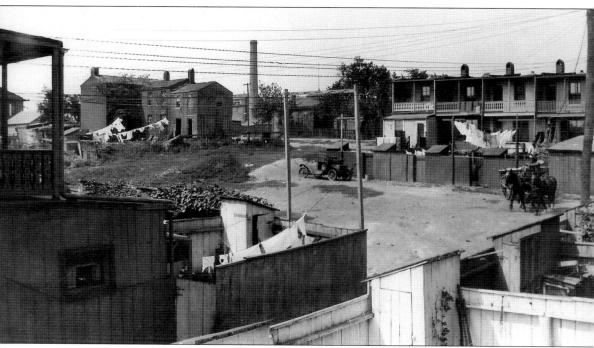

Living conditions in early Highlandtown could be crowded and foul smelling, as evidenced by this photograph taken in the rear of the 3800 block of Hudson Street in 1923. Outhouses or "earth closets" were in every yard, and stables were common. In addition, a south breeze off the water usually brought with it the unpleasant aromas of Canton-based industry. (Courtesy John Rockstroh.)

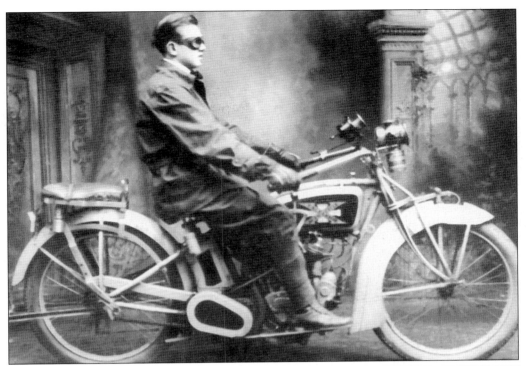

William Hoehn sits for a photographer in the early 1900s on the back of his motorcycle. In 1927, he would open Hoehn's Bakery at Third (Conkling) and Bank Streets. The bakery, famous for peach pie, éclairs, old-time smear (cheese) cake and more, continues to be family owned and operated at the same location today. (Courtesy Sharon Hoehn Hooper.)

This handsome young man is Christian Faulstich, who lived on Eleventh (Kresson) Street. He's seated on an antique three-cornered chair, popular with pre-20th-century military men, as its design accommodated their swords. This picture comes from the early 1900s. (Courtesy M. Rita Hubbel.)

The Whitman house, seen here on March 13, 1927, was for years used as offices for the National Brewing Company. It stood at the corner of Dillon and Dean (Fourth) Streets. (Courtesy John Rockstroh.)

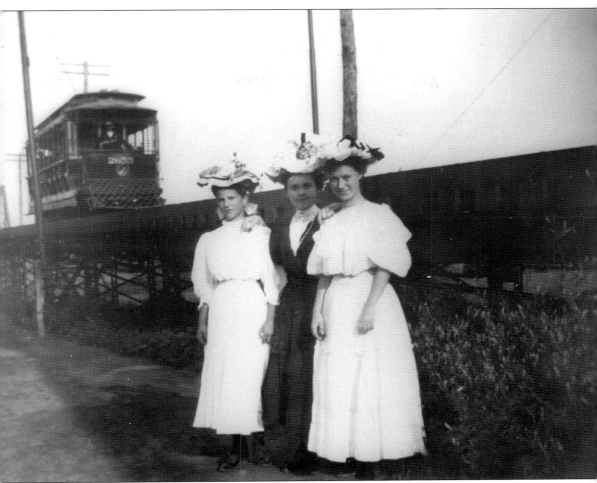

From left to right, Ruby Zoller, Theresa Fisher, and Mary Hershfield pose on August 18, 1907, as the Number 26 streetcar from Sparrows Point approaches from the rear along an elevated section of Lombard Street. (Courtesy Baltimore County Public Library.)

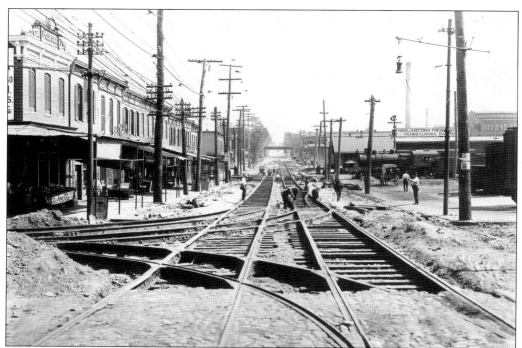

Work was underway on the streetcar tracks when this picture was snapped looking east along Eastern Avenue at Eighth (Haven) Street. At right, a freight train being pulled by a steam locomotive sits at the Pennsylvania Railroad's Highlandtown Freight Station. All the buildings on the left came down in the 1930s to make way for the underpass. This photograph was taken on September 17, 1915, and shows Highlandtown spelled as one word on the station's sign, although this did not become commonplace until 1919. (Courtesy the Maryland Rail Heritage Library of the Baltimore Streetcar Museum, Inc./Baltimore Chapter NRHS, Inc.)

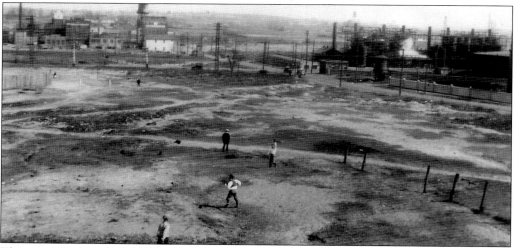

This rough-looking ball field was called Baker's Field, near the present-day intersection of Dillon and Dean Streets. To the right is O'Donnell Street. The viaduct passes over this location today. A portion of the once-massive Standard Oil Esso plant is visible at the right. This picture was snapped on April 3, 1927. (Courtesy John Rockstroh.)

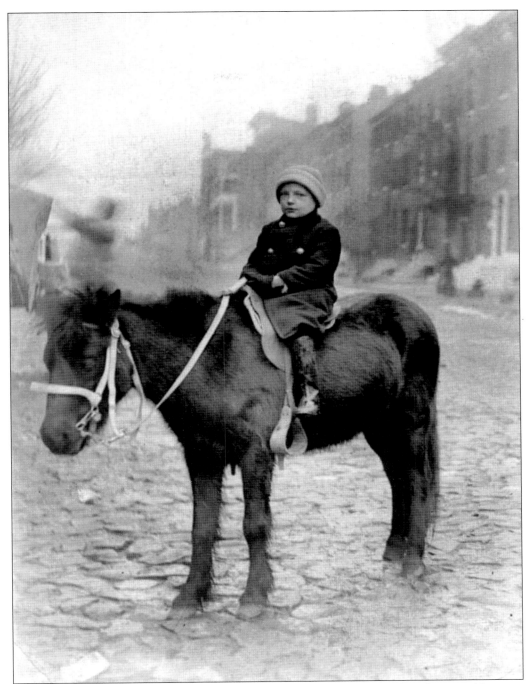

Pony rides were probably a nickel when Theodore Hartman climbed aboard on a cold winter day. The cobblestones of East Lombard Street are clearly visible in this shot, which was taken in 1909 or 1910. Theodore was the younger brother of Henry and Joe Hartman. (Courtesy Marilyn Blimline.)

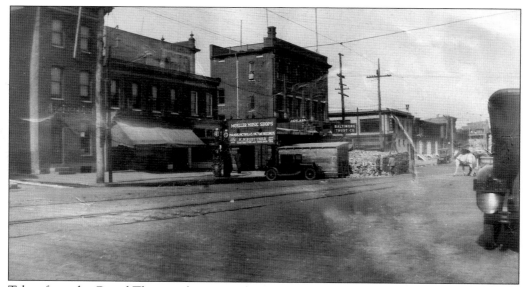

Taken from the Grand Theatre, this 1920s photograph shows the west side of Third (Conkling) Street at Eastern Avenue with a small gasoline station and the Baltimore Trust Company. A billboard advertises Mueller Music Shops on Fait Avenue. Wieland's Furniture and Louis J. Smith Sporting Goods later occupied this spot. (Courtesy John Rockstroh.)

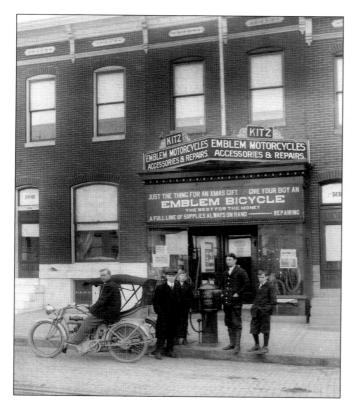

At Kitz Motors at 3239 East Baltimore Street, an Emblem motorcycle, complete with sidecar, fills up with Red Sentry gasoline. Suffice it to say the driver didn't pay $3 a gallon when this photograph was snapped in 1925. (Courtesy John and Frances Kitz.)

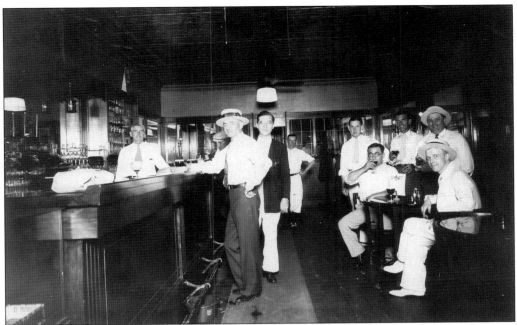

On a warm day around 1920, men (unescorted women were not admitted) down glasses of Monumental Beer at the Grand Café in the 500 block of South Third (Conkling) Street. Joseph Regan Sr. (1884–1955) is behind the bar at the left. His nephew John Regan can be seen in the foreground at the bar with the straw hat. The remaining patrons are unidentified. Regan was a major baseball fan who sponsored and/or managed local teams for years. Babe Ruth was reportedly an occasional customer. (Courtesy Patrick Shannon Regan.)

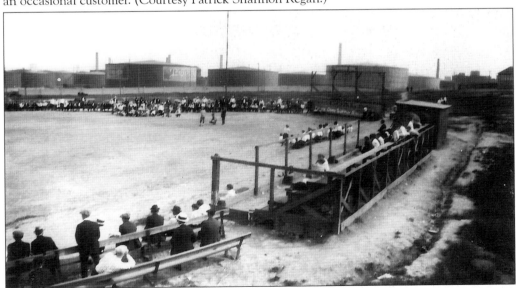

With O'Donnell Street and the Esso facility in the background, a respectable crowd was on hand to take in this baseball game at the Fernwood Oval. Long ago, Hudson Street had been called Fernwood Avenue. When the National Brewing Company expanded, the field disappeared. (Courtesy John Rockstroh.)

Patterson Park Junior/Senior High School had yet to open for students when this picture was snapped in 1934. When a new Patterson High School opened on Kane Street in 1960, this building became Hampstead Hill Junior High and later Highlandtown Junior High. It was closed in 2006. (Courtesy Bill Miller.)

The stinky job of cleaning out Highlandtown's "earth closets" fell to these two men, remembered today only as the Schlesingers. In the days before environmental protections, one can only imagine where a truckload of human waste was discarded back in 1924, when this photograph was taken. (Courtesy John Rockstroh.)

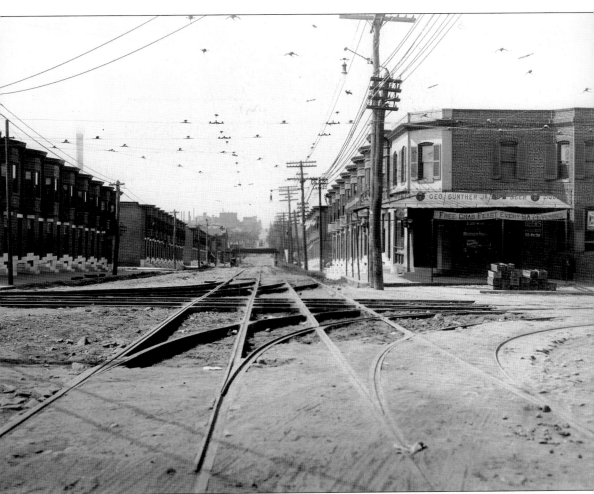

Eastern Avenue was practically impassable to what little traffic existed on September 17, 1915. That's when this shot was taken looking west from the intersection of Fifteenth (Oldham) Street. This section of Eastern Avenue, now Greektown, was largely residences at this time. The café on the corner to the right advertised Gunther Beer, and a banner declared "Free Crab Feast Every Sat. Evening." (Courtesy the Maryland Rail Heritage Library of the Baltimore Streetcar Museum, Inc./Baltimore Chapter NRHS, Inc.)

In this photograph, it's Eighth (Haven) Street that couldn't be navigated due to heavy rains on July 3, 1922. By now, Highlandtown was part of Baltimore City, but the municipality did not install sewer lines for a few more years. (Courtesy John Rockstroh.)

Two

WILLIAM PATTERSON'S PARK

William Patterson (1752–1835) was one of the wealthiest Marylanders of his time. A merchant and shipper, he purchased the 200-acre estate of Nicholas Rogers on the eastern boundary of Baltimore Town at Harris Creek for $8,500 in 1792. In 1827—the same year he became one of the founders of America's first railroad, the Baltimore and Ohio—Patterson donated six acres of the estate to the city for a public walk. Following his death, the city purchased additional acreage from his heirs. On July 13, 1853, Patterson's Walk officially became Patterson Park. (Courtesy Enoch Pratt Free Library.)

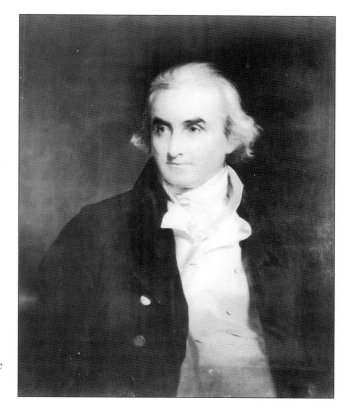

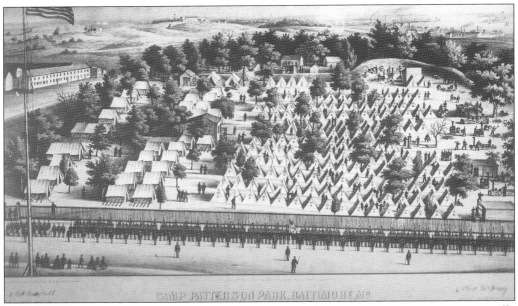

When the Civil War broke out, Baltimore, because of its Southern sympathies, was essentially placed under martial law. Union troops sent to occupy the city encamped in public parks and other open spaces. Camp Washburn was established on the grounds of Patterson Park at Hampstead Hill, also called Fort Hill. It was accompanied by a hospital, Camp Patterson Park, which remained until 1864. Many of the Union soldiers wounded at the Battle of Gettysburg convalesced here. (Courtesy Enoch Pratt Free Library.)

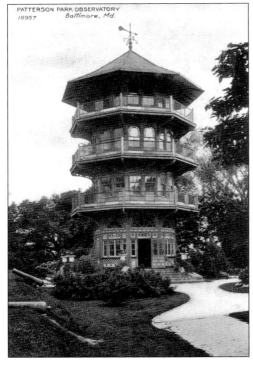

Baltimore parks superintendent Charles H. Latrobe was the grandson of architect Benjamin Henry Latrobe, who designed the south wing of the U.S. Capitol building, as well as Baltimore's Basilica of the Assumption. The younger Latrobe designed and built the Patterson Park observatory, later known as the Pagoda, in 1892, at a total cost of $18,875. This photograph appeared on a 1909 postcard. (From the author's collection.)

34

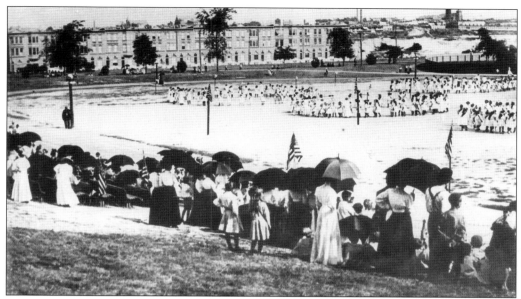

In 1909, a neighborhood children's association staged a play and sports festival in Patterson Park, on present-day Ortman Field. In the background is South Linwood Avenue, once known as Patuxent Street. (Courtesy Enoch Pratt Free Library.)

Engraved in a monument at the Eastern/Linwood Avenues entrance to the park is this tribute to Casimir Pulaski. Volunteering his service to the new United States of America, he distinguished himself as a brilliant military tactician, coming to the aid of Gen. George Washington at Brandywine. Pulaski was appointed brigadier-general in charge of the Four Horses Brigade. Later he became head of the first American cavalry. He was mortally wounded at the Battle of Savannah. His monument at Patterson Park was erected in 1951 and restored in 2001. (Courtesy Enoch Pratt Free Library.)

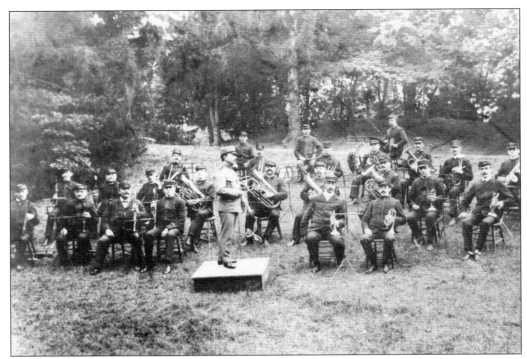

The Patterson Park Band, with conductor Dorsey Waters standing on a low podium, is seen in this photograph taken in 1905 or 1906. Swedish-born Bror Carl Bladin (1853–1910) is sitting in the second row, the second player to the right of the conductor. The other band members are unidentified. (Courtesy Baltimore County Public Library.)

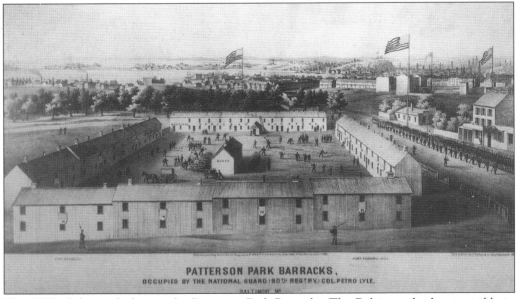

PATTERSON PARK BARRACKS,
OCCUPIED BY THE NATIONAL GUARD 190TH REGT R.V. COL. PETRO LYLE.
BALTIMORE MD

This 1860s lithograph depicts the Patterson Park Barracks. The Baltimore harbor is visible in the background, along with Canton to the left and Fells Point to the right. (Courtesy Enoch Pratt Free Library.)

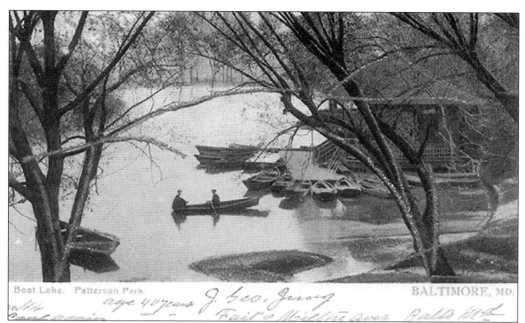

Boat Lake. Patterson Park.

BALTIMORE, MD.

The Patterson Park boat lake was inadvertently created in 1864 by earth-moving equipment that was being used to remove abandoned military encampments. The boat landing and shelter, seen in this early-20th-century postcard, were added in 1884. The boat lake was restored in 2002. (From the author's collection.)

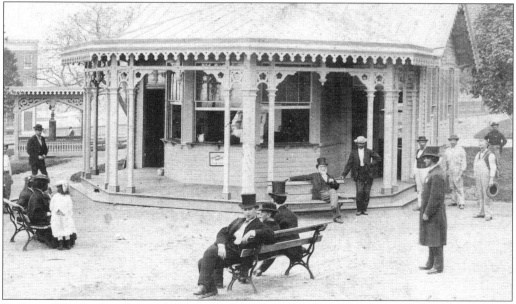

Built in 1871, the Ice Cream Saloon was also known as the Little Casino. A popular meeting spot, visitors could buy refreshments there or use its restroom facilities. It was situated adjacent to a carriageway across from the Pagoda. Homes along Patterson Park Avenue are visible in the background. This photograph is believed to be from the 1870s or 1880s. (Courtesy Jack and Beverly Wilgus.)

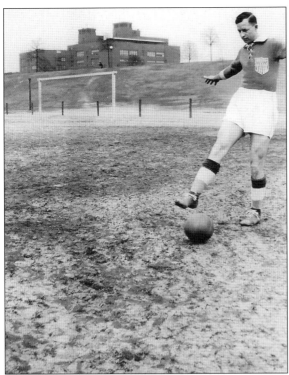

With School 43 in the background, amateur soccer player Tom Warga got in a little practice in the upper park during the 1930s. The popularity of soccer in Highlandtown over the years cannot be overstated. (Courtesy Carol Doroff.)

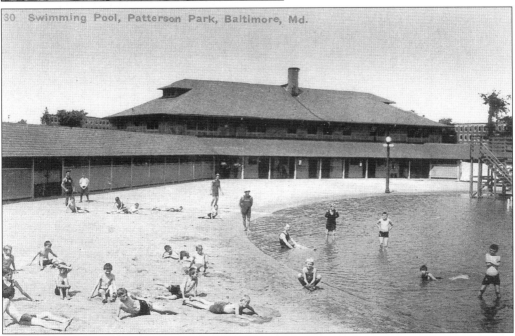

30 Swimming Pool, Patterson Park, Baltimore, Md.

The Tudor Field House was built in 1905. It included two wings on the southern side that served as bathhouses and extended diagonally to frame the circular-shaped swimming area. The wings were destroyed by fire in the 1970s. This postcard from the author's collection is from the 1930s.

Holding a rose, Tillie Miskowska Kielczewski struck this thoughtful pose for the camera on a Patterson Park bench in the 1920s. The Tudor Field House is visible at the rear. (Courtesy Florence Sdanowich.)

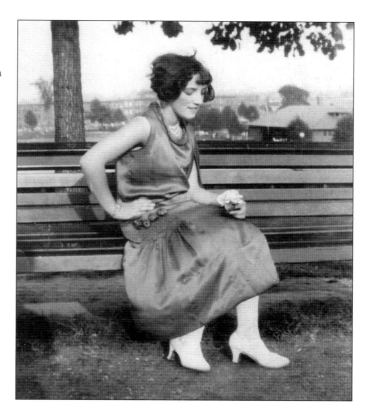

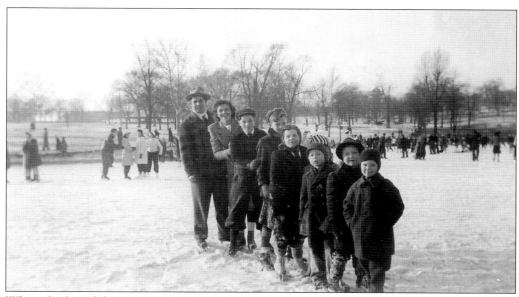

When the boat lake was accidentally formed in 1864, one of the first things the locals did on it was skate. The Lane family and friends take to the ice in this photograph around 1942. The contributor of this picture is fifth from the left. (Courtesy Betty Lane.)

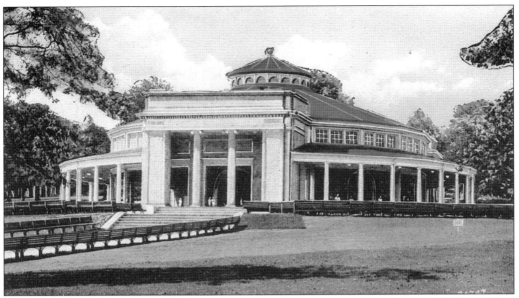

Known as the Music Pavilion, this Victorian structure built in 1924 was the scene of countless concerts and religious ceremonies over the years. It was destroyed by fire in 1972. This undated postcard is from the author's collection.

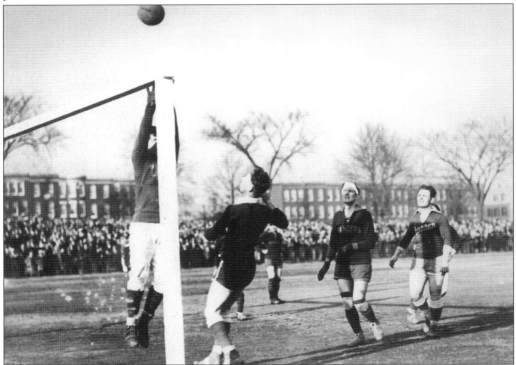

Here's a 1930s shot of two Police Athletic League teams engaged in a competitive game of soccer. The crowd in the background, despite the winter weather, is a testimony to the popularity of soccer in Highlandtown. (Courtesy Enoch Pratt Free Library.)

Cousins Margaret Fitzberger, Florence Vogler, and Jacob Kacher (from left to right) mug for the camera at the Patterson Park tennis courts in the 1940s. Tennis was a Sunday ritual for the trio. Matches often lasted from the end of church services until dusk. (Courtesy Florence Gundlach.)

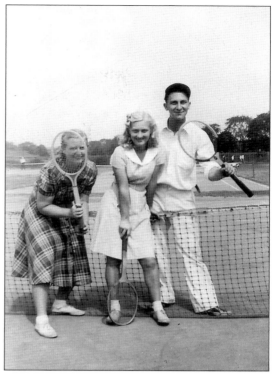

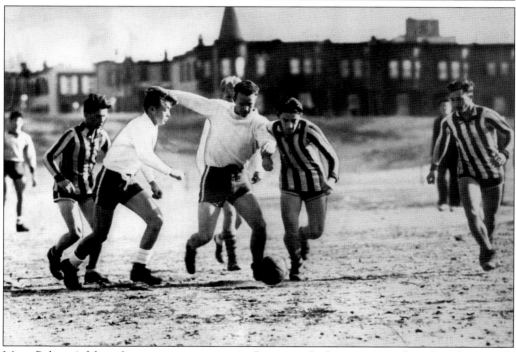

More Police Athletic League soccer action in Patterson Park was captured in this photograph from the 1930s. Teams and players were not identified. (Courtesy Enoch Pratt Free Library.)

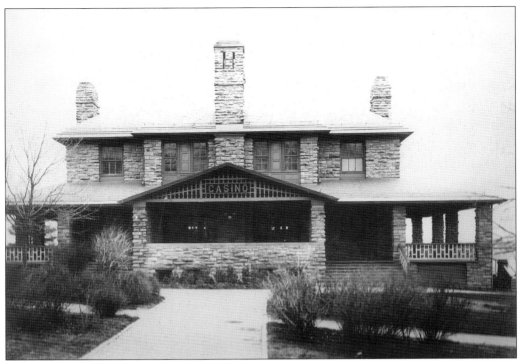

Like the Pagoda, the Patterson Park Casino was designed by Charles H. Latrobe and built in 1893. First used as a refreshment stand, the building now contains an adult day care facility and meeting rooms. (Courtesy Enoch Pratt Free Library.)

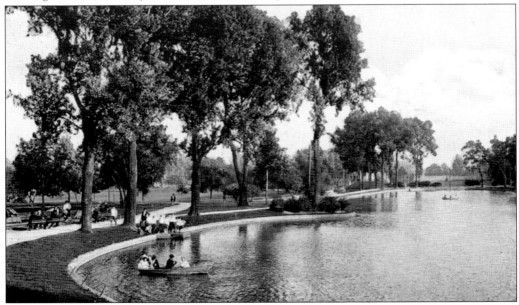

This later view of the boat lake comes from a 1920s or 1930s postcard. Considering Baltimore's oppressive summer heat and humidity, it's almost unfathomable that gentlemen were dressed in coat, tie, and hat while rowing.

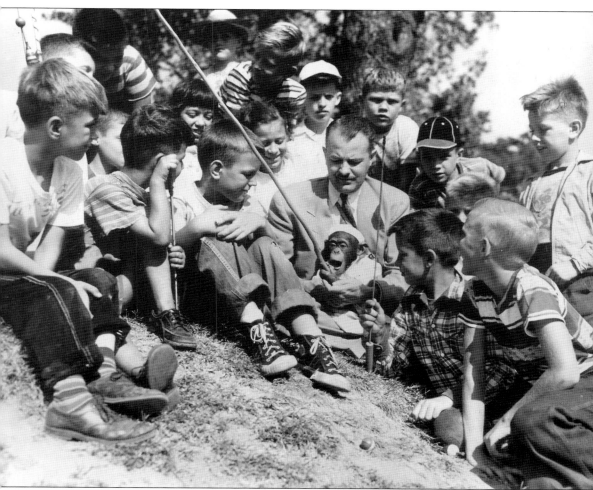

How many kids anywhere could say they went fishing with a chimpanzee? This group did in Patterson Park in the mid-1950s, with Baltimore Zoo director Arthur Watson and his famous primate, Betsy the Chimp. During her short but high-profile life (1951–1960), Betsy gained international fame with her finger paintings that were sold to generate revenue for the zoo. When she died in February 1960, her obituary, which was front-page news, described her as "the Picasso of the primates—the Jackson Pollack of the apes." (Courtesy Enoch Pratt Free Library.)

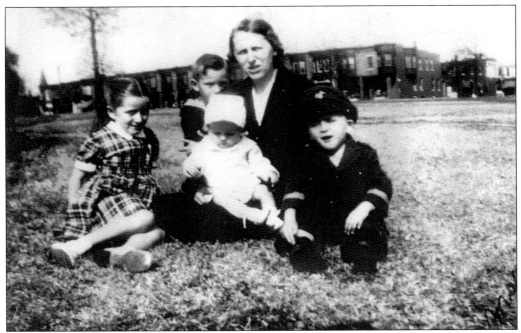

Patterson Park has been called the best backyard in Baltimore. As a venue for quality recreation and family time, it's priceless. In the early 1940s, Mary Piechocka and her children, (from left to right) Marie Piechocka, Joseph Piechocki, baby Thomas Piechocki, and Melvin Piechocki, did what countless families have done in the park over the years—just sat around enjoying each other's company. (Courtesy Marie Kijowski.)

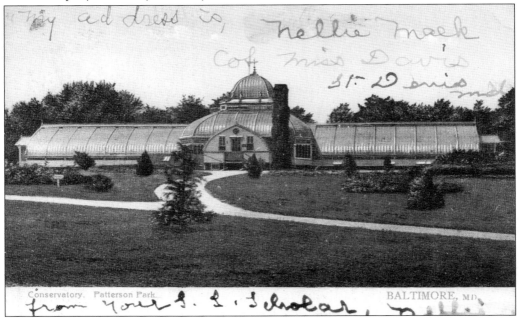

Nellie Meek mailed this postcard in the early 1900s. It features the Conservatory, which was erected in 1876. Razed in 1948, it is now the sight of a playground.

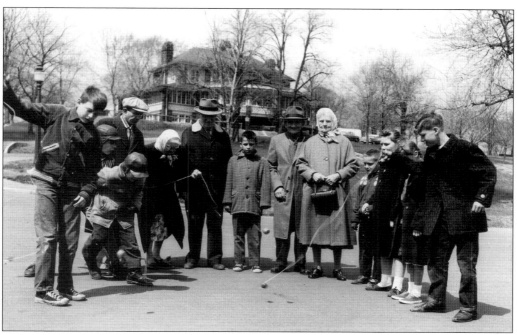

On April 6, 1961, members of the Golden Age Club of Patterson Park joined youngsters for a demonstration of top spinning. Exactly who was teaching who is unclear. The park's White House, built in 1866, is visible in the background. (Courtesy Enoch Pratt Free Library.)

The Potomac Reckers (named for Potomac Street) look a wreck after a pickup football game in the early 1950s. While not as popular as soccer, American football games were always common in the park. But pads and helmets weren't. (Courtesy Stanley "Stash" Sdanowich.)

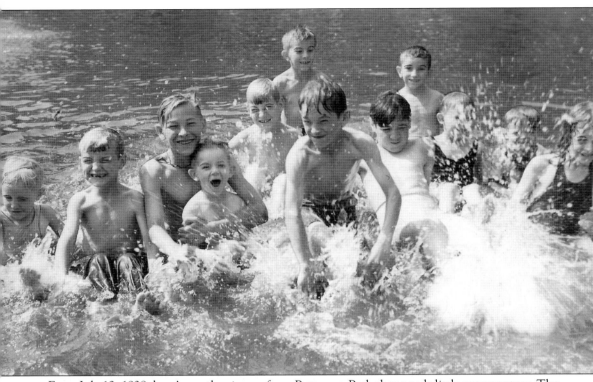

From July 12, 1938, here's another image from Patterson Park that needs little commentary. The sheer delight of these youngsters cooling off in the park is evident in their smiles. (Courtesy Enoch Pratt Free Library.)

Three

FOR GOD AND COUNTRY

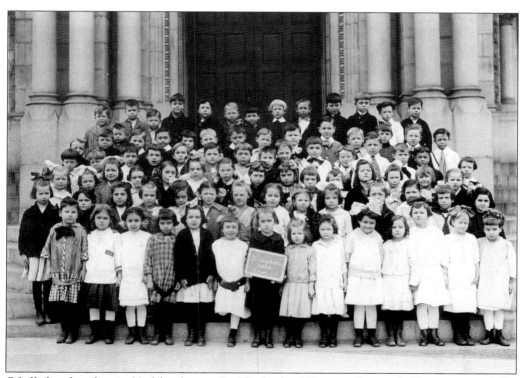

Of all the churches in Highlandtown, St. Elizabeth of Hungary has probably maintained the most extensive photographic record. Here dozens of first graders pose outside in 1916. (Courtesy Jean Jomidad.)

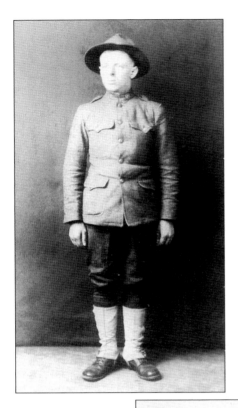

Pictured in his doughboy uniform, Highlandtown resident John Schmidt (1893–1946) served with pride during World War I. (Courtesy Elizabeth Adams.)

The spring weather was perfect for the May Procession at Sacred Heart of Jesus Church. Here the young ladies pass along Conkling Street walking toward Fleet Street on May 12, 1957. (Courtesy Elizabeth Adams.)

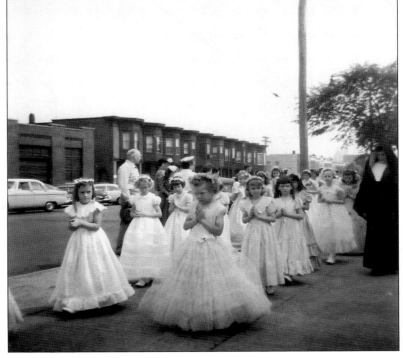

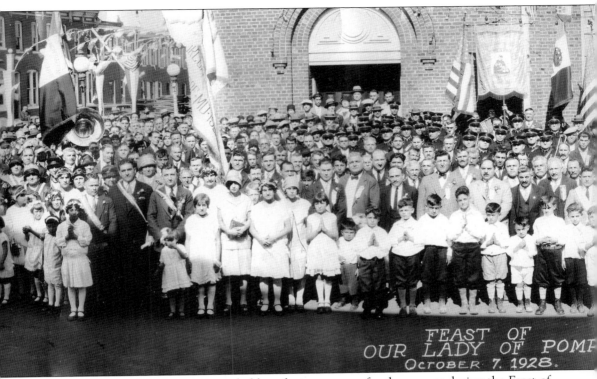

FEAST OF
OUR LADY OF POMF
October 7. 1928.

Hundreds of parishioners, young and old, took time to pose for the camera during the Feast of Our Lady of Pompei, on October 7, 1928. Uniformed members of the Pompei band, founded by Luigi DiPasquale Sr., can be spotted among those gathered, and the flag of Italy is visible at the left. (Courtesy Salva Zannino Marziali.)

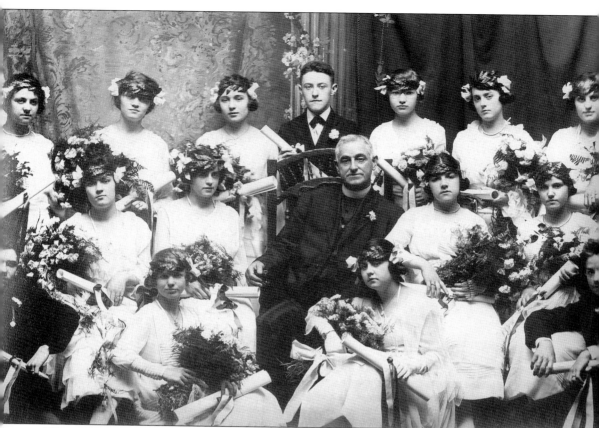

The graduating class of eighth graders from St. Elizabeth School posed for this photograph in 1919. Seated at the center is beloved pastor Rev. John J. Murray, who came to the East Baltimore Street church in 1903. Elevated to the rank of Domestic Prelate in the Papal Household, he became the Right Reverend Monsignor Murray in 1924 but remained pastor of St. Elizabeth until his death in 1951. (Courtesy Jean Jomidad.)

Like so many early residents, John Henry Vogler of 3919 Hudson Street served the nation during World War I. He posed in uniform for this photograph in 1917. (Courtesy Florence Gundlach.)

Church socials have been part of the fabric of Highlandtown since the area's first church, Canton Methodist, opened on Clinton Street in the fall of 1847. This photograph, taken in the late 1940s, shows members of the Holy Name Society hard at work in the kitchen of Sacred Heart of Jesus Church at Foster Avenue and Conkling Street. (Courtesy M. Rita Hubbel.)

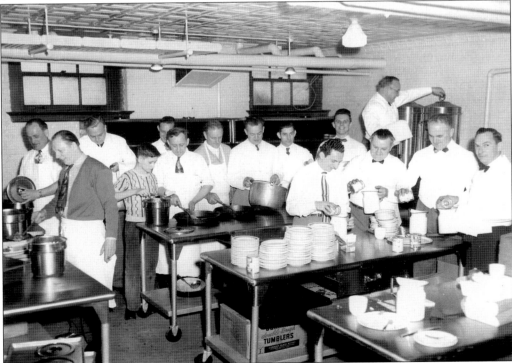

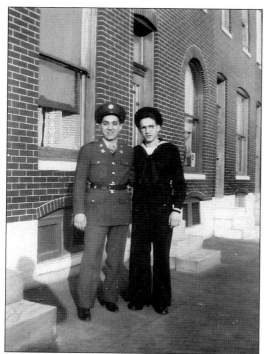

It's 1943, and the DiPasquale brothers, Louis (left) and Carmen, strike a friendly pose near the family grocery store on Claremont Street, forever putting to rest any suggestion that soldiers and sailors can't get along. (Courtesy Angie Knox.)

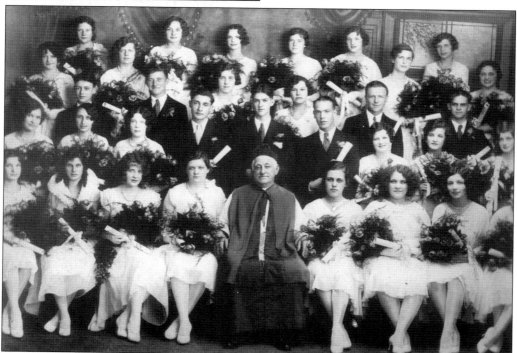

Monsignor Murray is front and center this time with the 1930 graduating class of eighth graders at St. Elizabeth. Founded in 1895, St. Elizabeth quickly outgrew its original parish. The current, larger building was dedicated in 1911. (Courtesy Jean Jomidad.)

The altar of the German United Evangelical Church was decorated for Confirmation ceremonies when this photograph was taken in April 1925, a year before the death of Rev. William Batz. The church was founded in 1874. (Courtesy Calvin Gundlach Jr.)

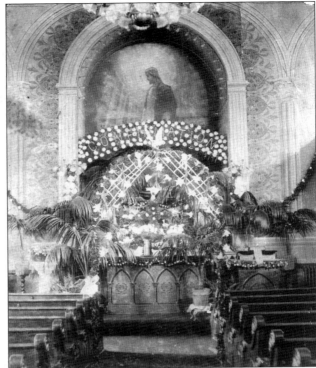

Luigi (Louie Moore) DiPasquale Sr. is seated at the far left, and Larry (Reds) DiMartino is seated at the far right. Between them is the Our Lady of Pompei Band, which the two men organized. This photograph is believed to be from the 1930s. (Courtesy Angie Knox.)

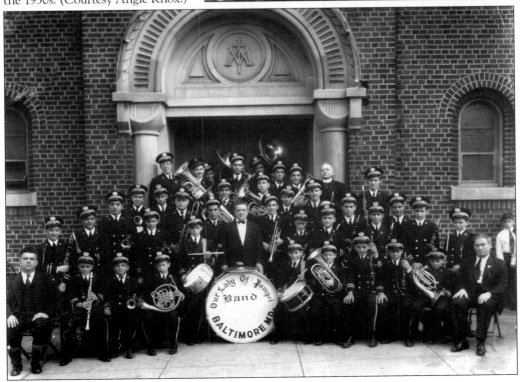

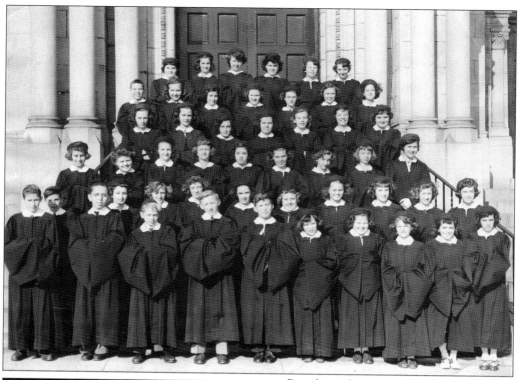

Proud members of the St. Elizabeth of Hungary Choir posed on the steps of the East Baltimore Street church in December 1949. The group sang Christmas carols on Baltimore radio station WCBM that year, accompanied by organist Anne Prendergast. (Courtesy Jean Jomidad.)

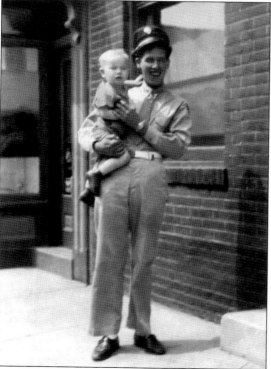

Edgar Colgan lived on Elliott Street in Canton before the war. Afterward he moved to Alabama. Before being discharged, he posed holding young Carl Brown on O'Donnell Street in 1945. (Courtesy Carl Brown.)

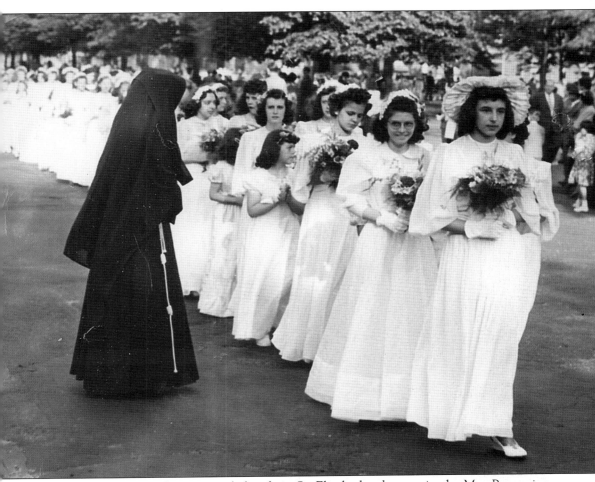

Under watchful eyes, these young ladies from St. Elizabeth take part in the May Procession in 1943, headed for the Music Pavilion in Patterson Park. During the war years, St. Elizabeth grew to become one of the largest Roman Catholic churches in all of Baltimore. (Courtesy Jean Jomidad.)

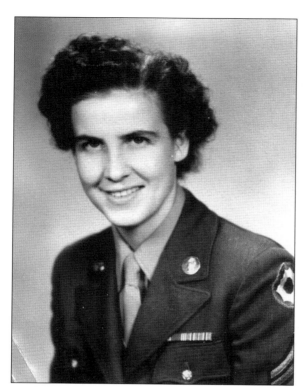

Geraldine Lane (1923–2002) enlisted in the Woman's Army Corps. (WACs) upon graduation from Seton High, and earned the rank of corporal. Her duties varied but included overseeing German prisoners of war at a facility in Seattle. (Courtesy Betty Lane.)

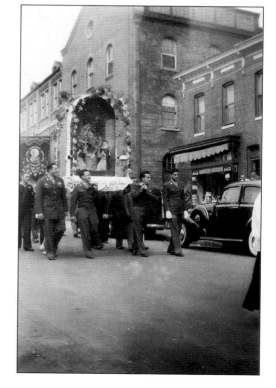

This very special May Procession at Our Lady of Pompei featured servicemen carrying the Blessed Mother along Conkling Street. While the date is uncertain, it is believed to be from 1946. (Courtesy Angie Knox.)

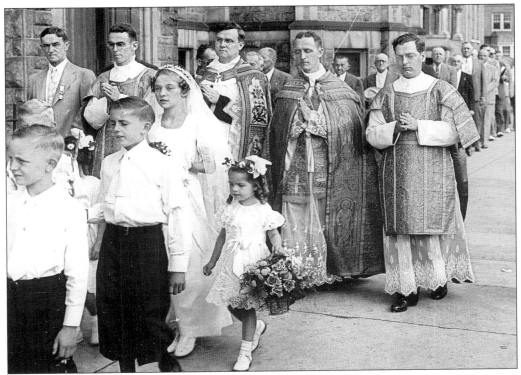

On July 30, 1939, Sacred Heart of Jesus celebrated the First Solemn High Mass of Fr. Louis Schenning, C.S.S.P. (second from the right). Christine Faulstich carried a ceremonial pillow embroidered with a timeline of significant dates in Father Schenning's pastoral life. A large crowd of Sacred Heart faithful followed along Conkling Street. (Courtesy M. Rita Hubbel.)

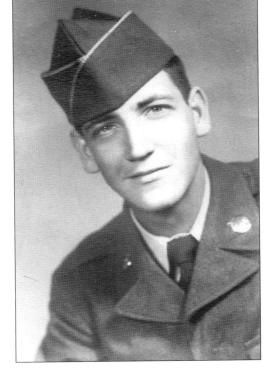

Since the Civil War, it's been customary for enlisted men to have a professional photograph of themselves taken in uniform to be sent home to family and friends. Highlandtown's Kenny Brown did that during World War II. (Courtesy Lisa Ciofani.)

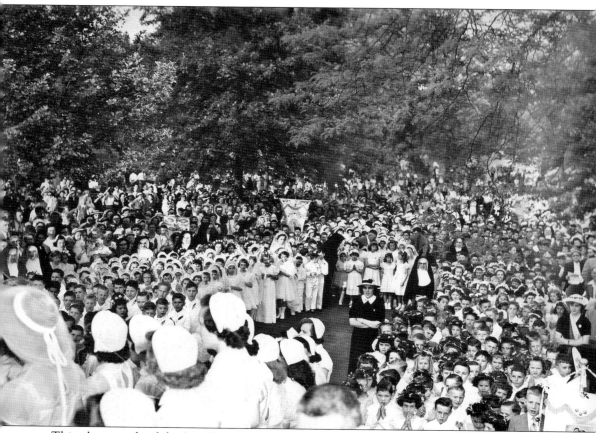

This photograph of the May Procession from St. Elizabeth to Patterson Park on May 4, 1950, depicts just how much the parish had grown since 1895. Most Reverend Jerome D. Sebastian was parish administrator from 1938 to 1951 and pastor from 1951 until his death in 1960. On February 14, 1954, he was consecrated auxiliary bishop of Baltimore. (Courtesy Jean Jomidad.)

It was the 1940s, and five Highlandtown servicemen all happened to be home at the same time. Celebrating with steamed crabs and beer on the white marble steps of Highland Avenue are, from left to right, Charles Gunner, Conrad Linz, Mitch Henry, Jimmy Hennigan, and Raymond Zeller. (Courtesy M. Rita Hubbel.)

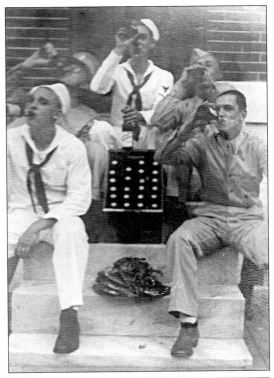

St. Bridget's Roman Catholic Church was founded in 1854 at Canton (Ellwood) Avenue and Hudson Street. The graduating eighth graders pose for this class picture in 1949. (Courtesy Florence Sdanowich.)

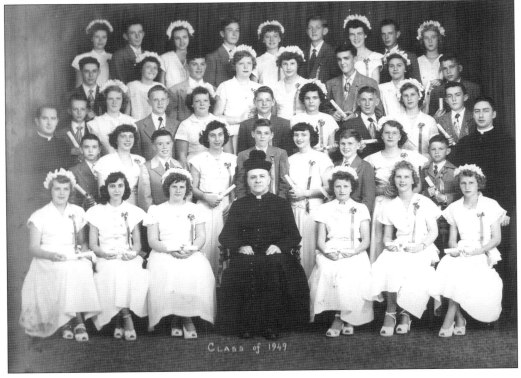

CLASS of 1949

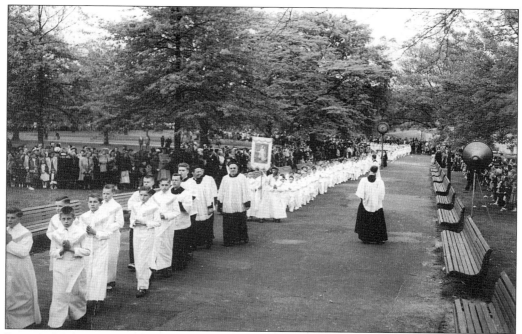

Reverend Sebastian presided over St. Elizabeth's May Procession in 1952. The annual ceremony took place in Patterson Park at the Music Pavilion until it burned down in 1972. (Courtesy Jean Jomidad.)

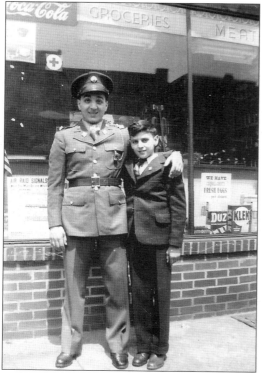

On leave and back home in 1943, Louis DiPasquale Jr. (left) poses with his proud nephew, Leo, in front of the family grocery store at 3700 Claremont Street. Now on Gough Street, DiPasquale's Italian Marketplace has been family owned and operated since 1914. (Courtesy Angie Knox.)

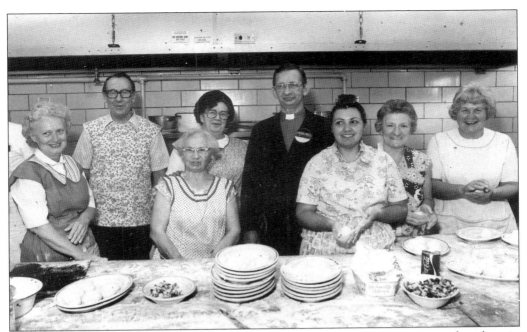

In the Friendship Hall kitchen at United Evangelical Church, members prepare potato dumplings in preparation for the annual sauerbraten dinner during the 1970s. Lifelong member Florence Gundlach is at the left. In the center is Pastor Scott Hengen. Sadly United discontinued the traditional fund-raiser in 2004 due to sagging church attendance. (Courtesy Florence Gundlach.)

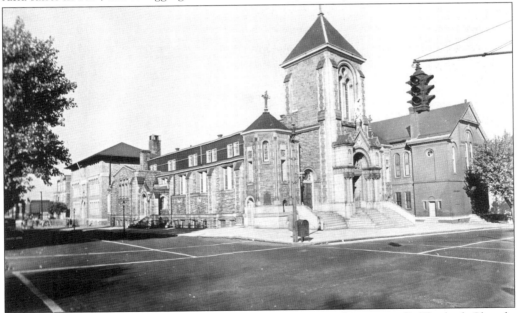

At the intersection of East Baltimore Street and North Lakewood Avenue is St. Elizabeth Church. The new (1911) parish and former school stand at the left; the structure on the right is the original church, which opened November 19, 1895. St. Elizabeth School is today Patterson Park Public Charter School. (Courtesy Enoch Pratt Free Library.)

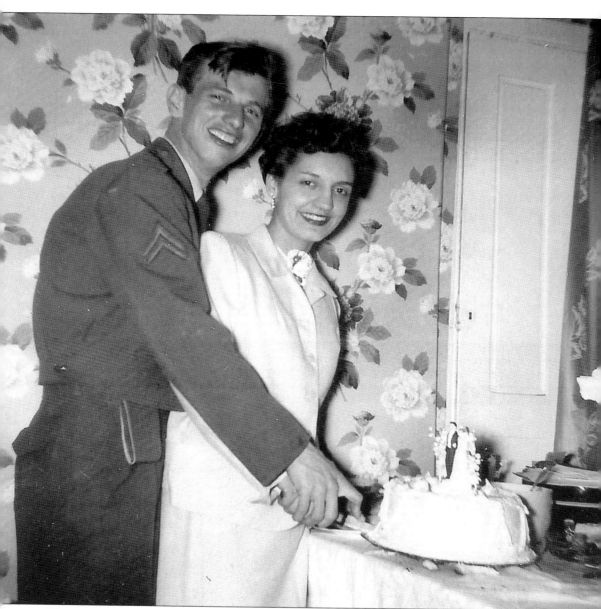

The end of World War II marked the start of the American baby boom. Servicemen returning from far-off venues wasted no time marrying the girls they left behind. Cutting their wedding cake in the mid-1940s are Highlandtowners Evie Brown and Eddie Henninger. (Courtesy Lisa Ciofani.)

In the backyard of their East Baltimore Street home, Christopher and Isabel (Izzy) Newman could now hold on to each other without the worry of anymore tearful good-byes or long separations. (Courtesy Mary Jane Tuma.)

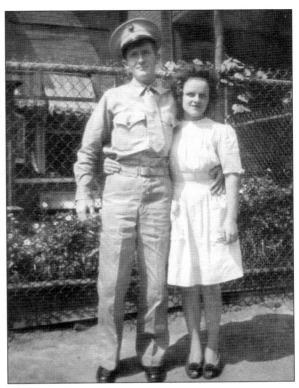

Seemingly untouched by the tempestuous events of a turbulent year, young Barbara Amend looks particularly angelic celebrating her first Holy Communion at St. Elizabeth Church in 1968. (Courtesy Jean Jomidad.)

John Michael Lane of South Bouldin Street had a good job with a great future as a welder at Bethlehem Steel in Sparrows Point. Family and friends called him Clark for his Gable-esque moustache. With a brother in the navy and a sister in the WACs, Lane decided to enlist in the marines in September 1944. After training, Clark was assigned to the USS *Nevada*. Brother Gilbert "Pete" Lane was serving aboard the carrier USS *Enterprise*. As fate would have it, both ships were together in the Pacific when the Japanese launched a kamikaze attack. Pete watched from the *Enterprise* as a Zero slammed into a gun turret on the *Nevada*. He had no way of knowing at the time, but his brother Clark and 17 other men were on that gun. A few of them made it out alive; John Michael "Clark" Lane didn't. (Courtesy Betty Lane.)

Four

THE AVENUE

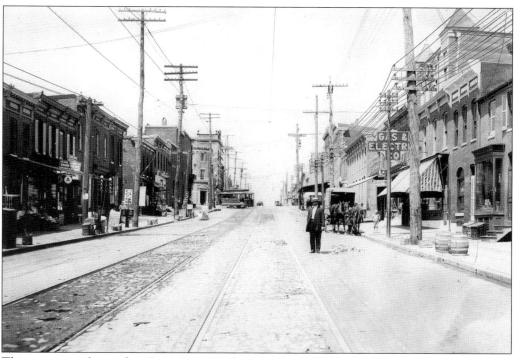

This awesome shot, taken June 21, 1915, features the 3700 block of Eastern Avenue looking west between Fourth (Dean) and Fifth (Eaton) Streets. The Number 34 streetcar can be seen turning onto eastbound Eastern from Third (Conkling) Street, passing buildings that would be demolished with the Grand Theatre in 2004. The Gas and Electric Company to the right is the present site of Eastern House restaurant. (Courtesy the Maryland Rail Heritage Library of the Baltimore Streetcar Museum, Inc./Baltimore Chapter NRHS, Inc.)

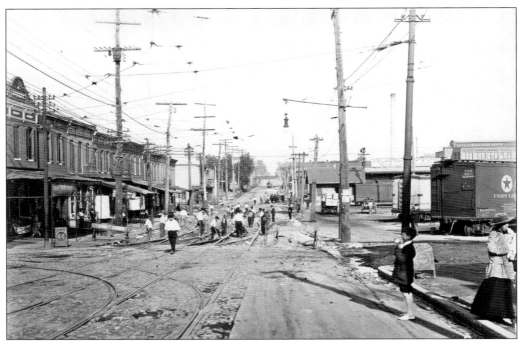

On August 31, 1915, a photographer set up his equipment on the Avenue at Eighth (Haven) Street facing east. Workmen were filling in the area around the streetcar tracks with cobblestones. In the foreground at the right, a young boy in knickers enjoys an ice cream cone from Horn's. All the buildings on the left were demolished in the 1930s for the Eastern Avenue underpass. (Courtesy the Maryland Rail Heritage Library of the Baltimore Streetcar Museum, Inc./Baltimore Chapter NRHS, Inc.)

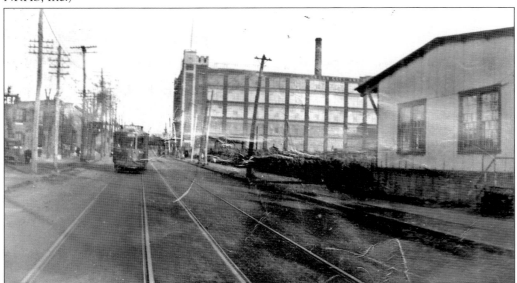

That's the Number 23 streetcar headed west on Eastern Avenue at Tenth (Janney) Street in the 1920s or 1930s. Crown Cork and Seal is to the right. This section of Eastern Avenue disappeared when the underpass was built in the 1930s. (Courtesy John Rockstroh.)

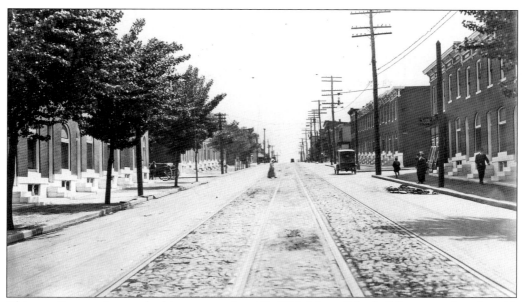

This was Eastern Avenue looking east on June 21, 1915. Most of the buildings were less than 10 years old, and almost all along this stretch of the Avenue were still private dwellings. On the right at Bouldin Street was "City Block Building Association No. 4." Across the street to the left, a delivery wagon marks the present location of Bolewicki's Appliances at 3222 Eastern Avenue. (Courtesy the Maryland Rail Heritage Library of the Baltimore Streetcar Museum, Inc./Baltimore Chapter NRHS, Inc.)

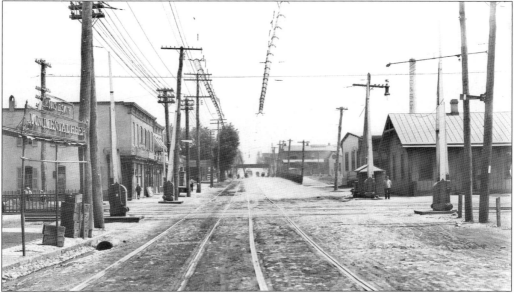

Louis E. Smith's saloon (left) was on the northwest corner of Eastern Avenue at Eighth (Haven) Street in this 1915 photograph. At least two additional bars were in the next block, along with a store advertising fireworks for sale. The Highlandtown Freight Station is to the right. (Courtesy the Maryland Rail Heritage Library of the Baltimore Streetcar Museum, Inc./Baltimore Chapter NRHS, Inc.)

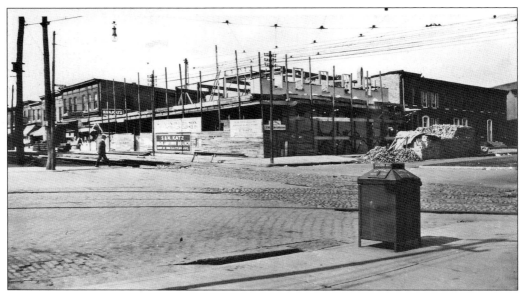

It's the early 1920s, and the S&N Katz Building is under construction on the northwest corner of Eastern Avenue at Third (Conkling) Street. There are no parking meters or traffic control devices in use at this time. (Courtesy John Rockstroh.)

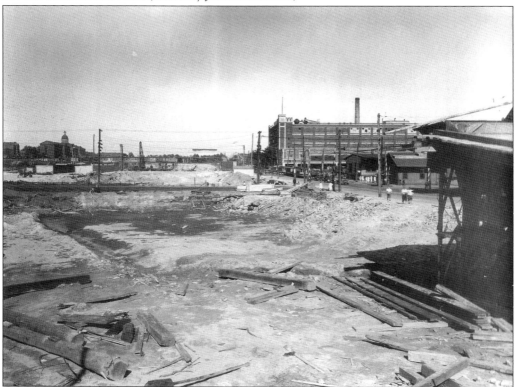

Bricks and other debris from demolished buildings can still be seen along Eastern Avenue to the right as work on the underpass begins in the 1930s. (Courtesy Enoch Pratt Free Library.)

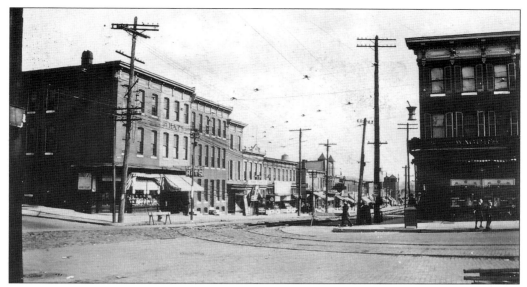

This time (October 7, 1922), the camera faces east at Eastern Avenue and Third (Conkling) Street. Wager's Pharmacy is on the right. At the center on the north side of Eastern Avenue (3610) is the Eagle, which showed silent films from 1908 to 1927. The building later became Terry's Gift Shop. This may be the only existing photograph of that tiny theater. (Courtesy John Rockstroh.)

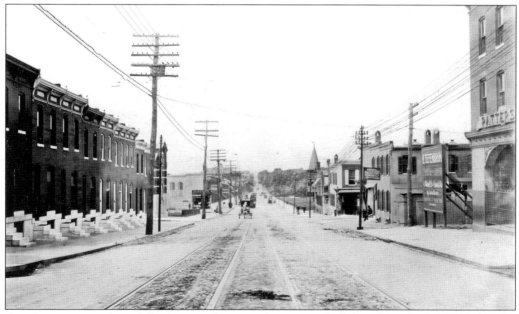

Another awesome shot of the Avenue shows row houses on the left and, in the foreground at the right, the original Patterson Theatre, which opened in 1910. The distinctive cupola of the house at Eastern and Canton (Ellwood) Avenues is visible just right of center. The house and cupola remain today. Behind it is Patterson Park. This was the city/county line (East Avenue) when this photograph was taken on May 10, 1915. (Courtesy the Maryland Rail Heritage Library of the Baltimore Streetcar Museum, Inc./Baltimore Chapter NRHS, Inc.)

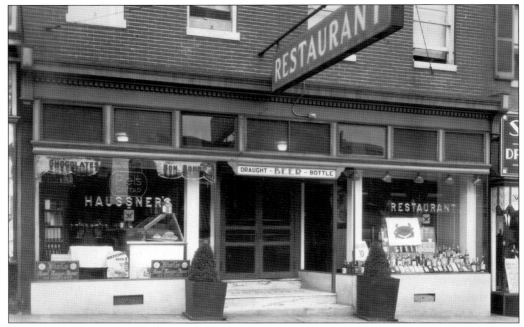

The original location of Haussner's Restaurant was on Eastern Avenue, next to Stella's Dress Shop. William Henry Haussner (1894–1963) came to Baltimore from Bavaria in 1925, opening this restaurant the next year. Haussner's remained at this location until 1936. Look closely at the small sign in the window on the right. It advertises crab cakes for 10¢! (Courtesy Southeast Community Development Corporation.)

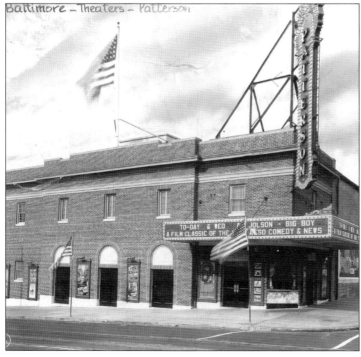

It was 1930, and the Al Jolson film *Big Boy* was playing at the brand new Patterson Theatre, at Eastern and East Avenues. Admission on this day was 15¢ for adults and a dime for kids. The Patterson was managed by the Grand Theatre Company, an affiliate of Durkee Enterprises, which razed the original theater in 1929. The new Patterson opened September 1930 and remained a Highlandtown institution until 1995. Today the building is home to the Creative Alliance. (Courtesy Enoch Pratt Free Library.)

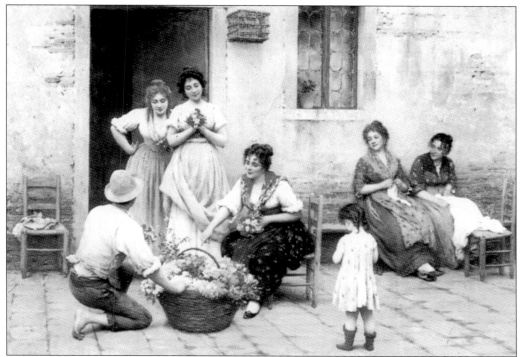

Haussner's was as much an art gallery as it was a great restaurant. Frances and William Henry Haussner began collecting artwork in 1940 and never paid more than $3,000 for a painting. This one, *Venetian Flower Vendor* by Eugene De Blaas, was the first painting they acquired. Sold at auction in 2004, it fetched an impressive $730,000. (Postcard from the author's collection.)

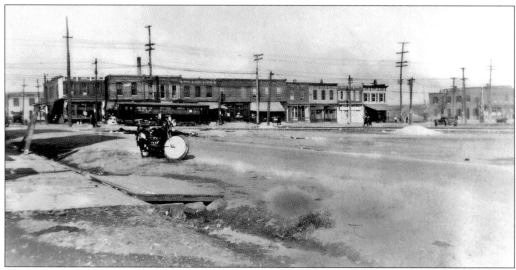

This early model motorcycle sat parked on Eighth (Haven) Street while, in the background, a streetcar bound for Dundalk headed east along the Avenue on October 1, 1922. (Courtesy John Rockstroh.)

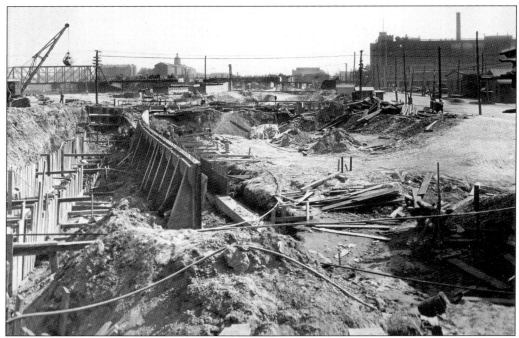

Construction of the underpass continued through the mid-1930s. Forms for the north wall were now clearly visible to the left. (Courtesy Enoch Pratt Free Library.)

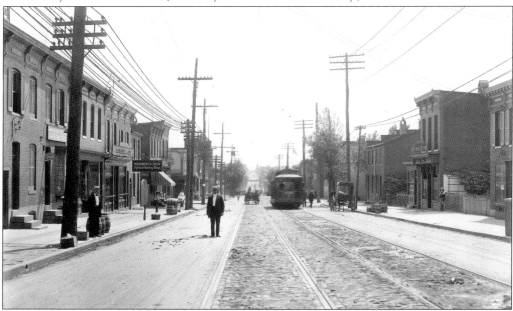

On June 21, 1915, Mr. Joseph H. Pratt, assistant general manager for United Railway and Electric Company, poses in the street in the 3700 block of Eastern Avenue. In this shot, which looks east, the Number 10 streetcar has just passed and is about to cross Fifth (Eaton) Street. To the left, a bar advertises Monumental Beer and the Highland Bowling Lanes. (Courtesy the Maryland Rail Heritage Library of the Baltimore Streetcar Museum, Inc./Baltimore Chapter NRHS, Inc.)

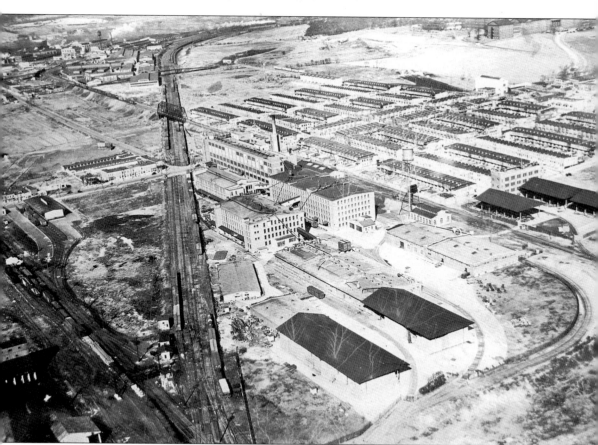

This aerial shot from the 1920s features the Crown Cork and Seal plant on Eastern Avenue, which boasted having seven acres of workspace inside. The Highlandtown Freight Station is at the left, at Eastern and Eighth (Haven) Street. The Northern Central tracks cut through the middle, connecting the Pennsylvania Railroad's mainline at the top with the Canton docks. Rows of houses at the right represent modern-day Greektown. (Courtesy Crown Holdings.)

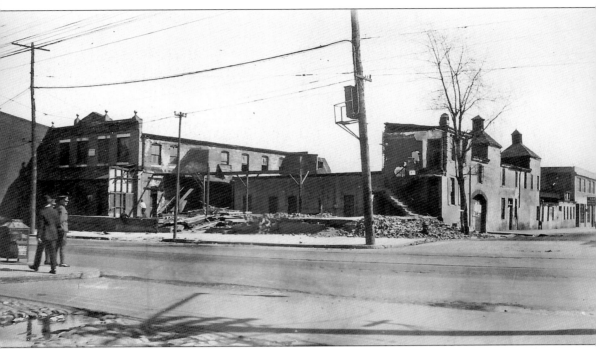

The Markets at Highlandtown presently occupy this site, the southwest corner of Eastern Avenue at Fifth (Eaton) Street. Demolition was underway when this photograph was shot on March 30, 1924. Luby Chevrolet and an Amoco gasoline station later occupied this location. (Courtesy John Rockstroh.)

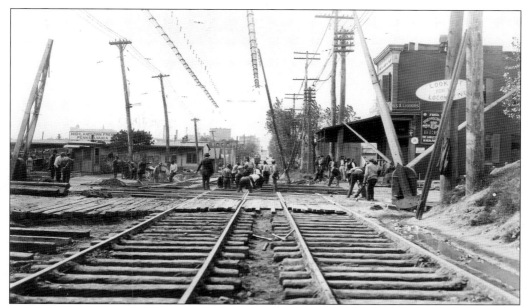

From Eleventh (Kresson) Street looking west, United Railway and Electric Company track workers labor on the streetcar/freight train intersection. Back then, crossing gates were manually operated by railroad watchmen. The streetcars' overhead catenary lines were reinforced where they intersected with freight trains. The Grand Theatre, until 2004 the tallest structure in Highlandtown, can be seen in the background of this September 27, 1915, photograph. (Courtesy the Maryland Rail Heritage Library of the Baltimore Streetcar Museum, Inc./Baltimore Chapter NRHS, Inc.)

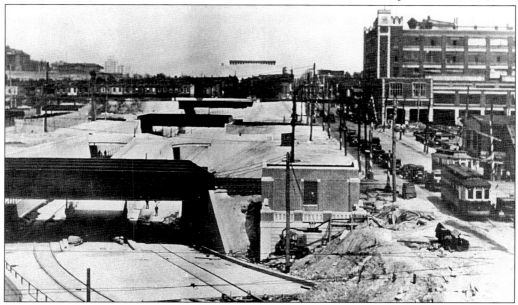

The underpass was nearing completion in this photograph from the 1930s. Eastern Avenue is at the right, and between the construction, railroad crossings, and streetcars, westbound traffic seemed to be moving at a snail's pace on this day. (Courtesy the Maryland Rail Heritage Library of the Baltimore Streetcar Museum, Inc./Baltimore Chapter NRHS, Inc.)

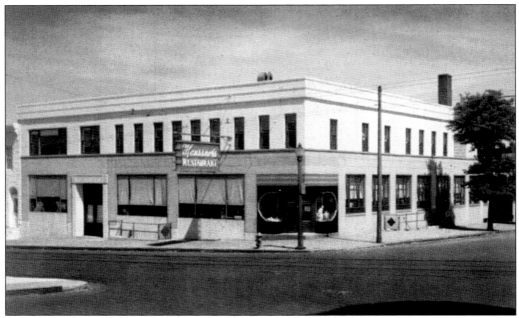

This postcard image from the late 1930s or early 1940s shows Haussner's after it moved to its permanent location on the northwest corner of Eastern Avenue and Clinton Street. Writer H. L. Mencken was a regular diner at the Highlandtown landmark. (Courtesy Marion Zych.)

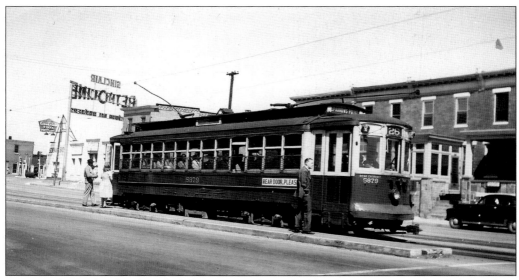

Here's a classic that locals called the "Red Rocket," the Number 26 streetcar headed east from Highlandtown to Sparrows Point. It was stopped at Eastern Avenue near Cornwall Street just past City Hospitals to pick up passengers when this shot was taken in the 1940s. (Courtesy Marion Zych.)

Waiting for the Easter parade along the 3700 block of Eastern Avenue around 1955 are, from left to right, Michael Schmidt, Debbie Malashuk, Patricia Ann (Pam) Malashuk, and Elizabeth Schmidt. Visible across the street is Hill's, a clothing store, the Ideal 5-and-10, and Kramer's, famous for caramel popcorn and rock candy. (Courtesy Elizabeth Adams.)

Jane Ellen Lane clearly enjoyed her job at F. W. Woolworth on the Avenue, as this photograph from the early 1950s suggests. Woolworth's, and the Kresge's next door, featured great toy departments, not to mention soda fountains. (Courtesy Betty Lane.)

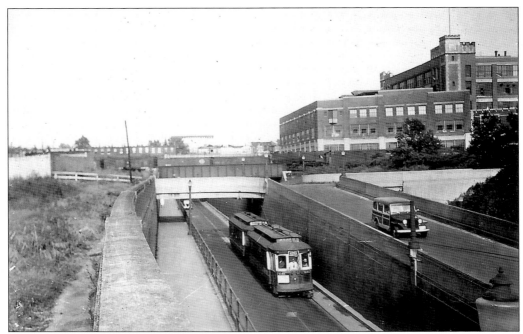

A "double-header" Red Rocket (the nickname for two streetcars coupled together) from Sparrows Point was photographed heading west in the underpass on August 2, 1947. Meanwhile, to the right, an early civilian Jeep was descending the ramp from Janney Street. (Courtesy the Maryland Rail Heritage Library of the Baltimore Streetcar Museum, Inc./Baltimore Chapter NRHS, Inc.)

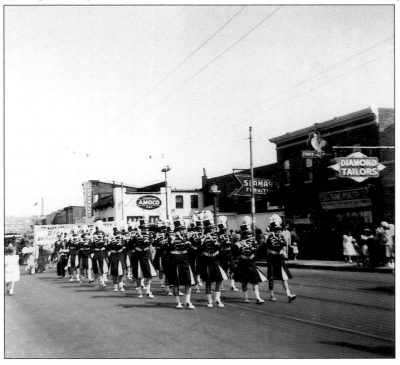

This parade procession was headed west on the Avenue at Eaton Street in the 1950s, passing Seaman's Furniture, Essex Farms Poultry, and Diamond Tailors. In the background, Luby Chevrolet is visible, next to a long-gone Amoco station. (Courtesy Elizabeth Adams.)

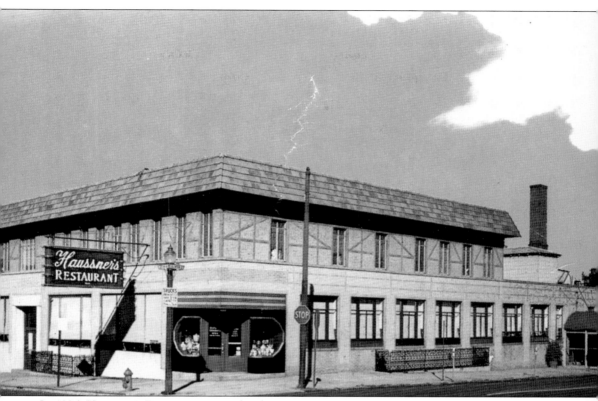

In 1936, Haussner's Restaurant moved to larger quarters across the street at Eastern Avenue and Clinton Street. This shot, from the late 1930s or early 1940s, shows separate entrances for the bar and dining room and large windows. Minor renovations were made over the years, and Haussner's remained popular until the day it closed in September 1999. (Courtesy Marion Zych.)

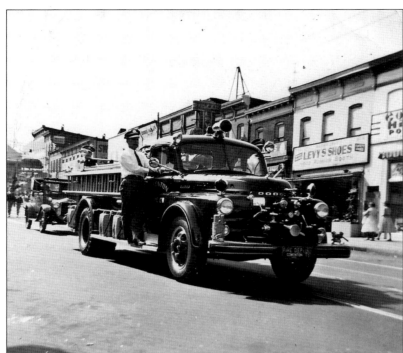

The 1955 Avenue Easter parade included this Dodge fire engine from the Cowenton Volunteer Fire Company in Baltimore County. Across the street, Oscar and Roger Levy's shoe stores can be seen, along with Colony Hill Poultry. (Courtesy Elizabeth Adams.)

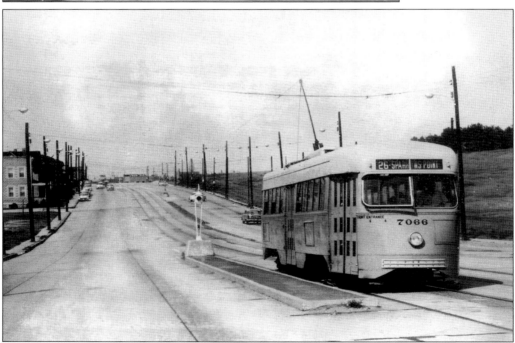

The last model streetcar to maneuver through Baltimore was the Pullman Presidential Coach, or PCC. Here Baltimore Transit Company's Number 7066 passed City Hospitals on Eastern Avenue en route to Sparrows Point. The Number 26 streetcar line was replaced with buses in 1958. This photograph was taken the year before. (Courtesy Southeast Community Development Corporation.)

Snyder's, at 3318 Eastern Avenue, sold stylish men's clothing at reasonable prices, as this 1953 advertisement reflected. Telephone prefixes, such as Dickens, were dropped in the 1960s. (Courtesy the *Baltimore Guide*.)

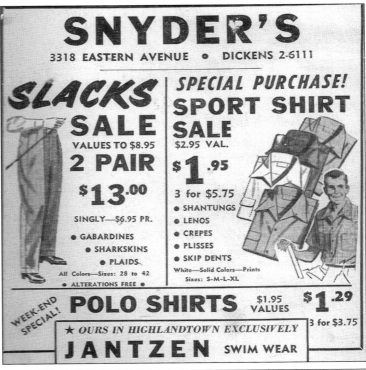

SNYDER'S

3318 EASTERN AVENUE ● DICKENS 2-6111

SLACKS SALE

VALUES TO $8.95

2 PAIR $13.00

SINGLY—$6.95 PR.

● GABARDINES
● SHARKSKINS
● PLAIDS

All Colors—Sizes: 28 to 42
● ALTERATIONS FREE ●

SPECIAL PURCHASE! SPORT SHIRT SALE

$2.95 VAL.

$1.95

3 for $5.75

● SHANTUNGS
● LENOS
● CREPES
● PLISSES
● SKIP DENTS

White—Solid Colors—Prints
Sizes: S-M-L-XL

WEEK-END SPECIAL! **POLO SHIRTS** $1.95 VALUES **$1.29** 3 for $3.75

★ OURS IN HIGHLANDTOWN EXCLUSIVELY

JANTZEN SWIM WEAR

Duckpin bowling was tremendously popular in Highlandtown through the 1960s. There were lanes on Conkling, Fleet, and Eaton Streets as well as the Avenue. Today only Patterson Lanes remains, at 2105 Eastern Avenue. Opened in 1927, it is the oldest duckpin bowling center in the world. (Courtesy Julia Ruzin.)

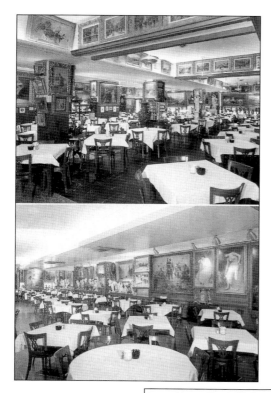

For those who weren't fortunate enough to dine at Haussner's, this image offers some idea how much art was on display at the restaurant. William Henry Haussner began his career in his native Germany during the 1920s as a chef at Nuremberg's Museum Restaurant, which occupied a former art gallery. (From the author's collection.)

Ever just have one of those days? That may have been what the unfortunate driver of this waterlogged car was thinking. The Eastern Avenue underpass has long had a reputation for flooding out after a heavy rain. Such was the case on this day in August 1959. The two youngsters in bathing caps swimming alongside the stranded auto couldn't have made the driver feel any better. (Courtesy Marion Zych.)

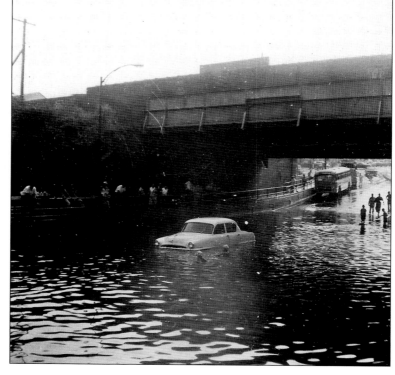

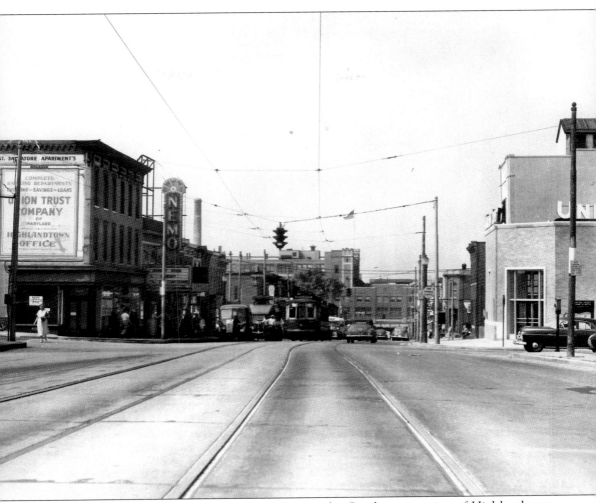

Looking west on Eastern Avenue at Ponca Street, the Greektown section of Highlandtown was for years a traffic bottleneck. The eventual elimination of streetcars plus recent parking restrictions have eased congestion somewhat. The old Nemo Theatre is visible to the left in this 1949 photograph. (Courtesy the Maryland Rail Heritage Library of the Baltimore Streetcar Museum, Inc./Baltimore Chapter NRHS, Inc.)

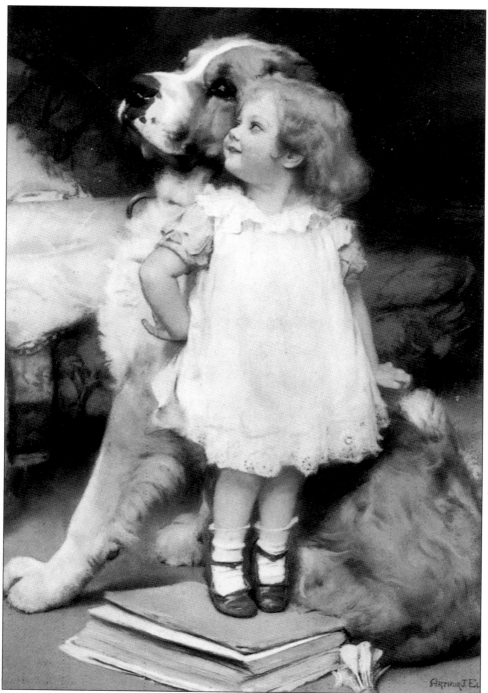

This beautiful painting, *I'se Biggest* by English artist Arthur J. Elsley, was part of the incredible collection at Haussner's Restaurant. After the restaurant closed in September 1999, the collection was sold at auction. Estimated to be worth $250,000, it sold for $673,500 at Sotheby's on November 2, 1999. (From the author's collection.)

Five

REFLECTIONS

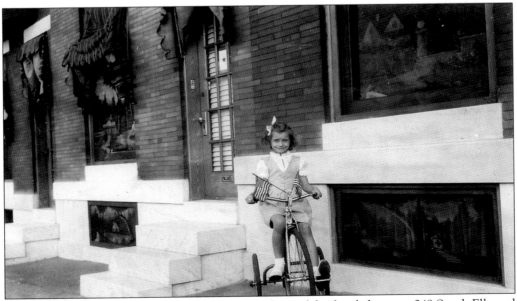

Pretty, young Carol Sealover stops her tricycle in front of the family home at 249 South Ellwood Avenue long enough to pose for this shot in the mid-1940s. Behind her are excellent examples of Highlandtown's famous painted screens. (Courtesy Carol Doroff.)

Original residents of Highlandtown referred to cars as "machines." This one had no trouble finding a parking place on East Avenue near Baltimore Street on January 8, 1917. To the left is Weber's Café, offering "Perfect Brew on Draught." (Courtesy the Maryland Rail Heritage Library of the Baltimore Streetcar Museum, Inc./Baltimore Chapter NRHS, Inc.)

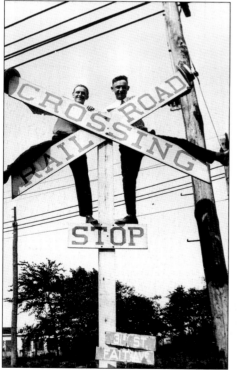

At Fait Avenue and Thirty-first (Gusryan) Street on the eastern outskirts of Highlandtown, Charles Behr (left) and John Rockstroh (right) clown atop a railroad crossing sign in 1923. (Courtesy John Rockstroh.)

The Faulstich family and their bakery were housed at 706 S. Highland Avenue from 1894 until the 1950s. Mueller Street is visible at the left. This photograph is believed to be from 1937. (Courtesy M. Rita Hubbel.)

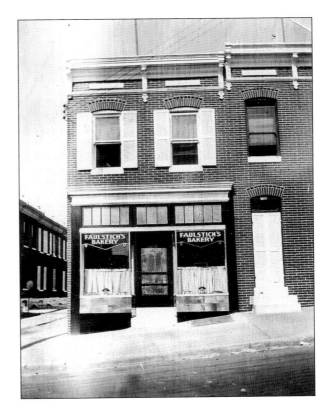

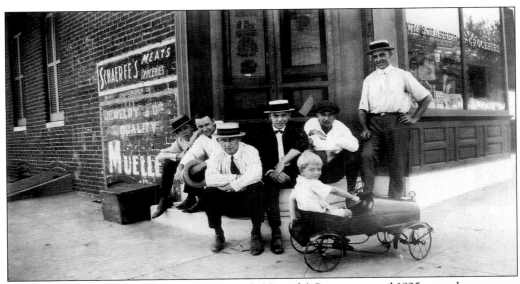

Back at Schaerfe's Corner, Hudson and Seventh (Grundy) Streets, around 1925, straw hats suggest it's summertime. Check out the peddle car that youngster is driving. (Courtesy John Rockstroh.)

Prohibition ended in 1933. Sometime afterward, friends, pictured from left to right, Luigi Graziaplena, Emilio Terzigni, and Angelo Ferri enjoy a brew in front of the Highlandtown Café at Claremont and Fagley Streets. Roma Sausage Company can be found there today. (Courtesy Marlene Donohue.)

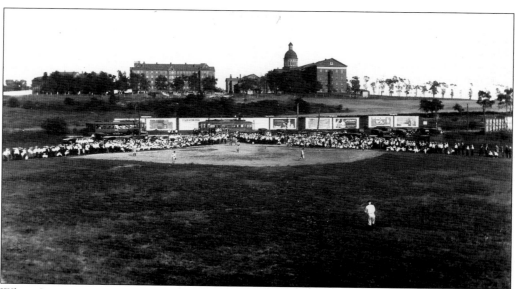

White Swan Park was adjacent to Sixteenth (Ponca) Street between Lombard Street and Eastern Avenue. Streetcars passed right by, minimizing the need for players and fans to come in a "machine." Bay View is in the background. The Baltimore Harbor Tunnel Thruway runs through the site now. (Courtesy John Rockstroh.)

Posing in the back yard of his home at Clinton Street and Foster Avenue, Tom Warga (1912–1980) models his Baltimore Americans sweater around 1930. Warga was one of Highlandtown's top amateur soccer players. (Courtesy Carol Doroff.)

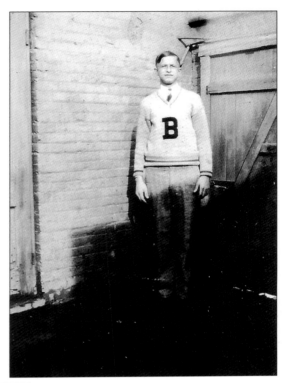

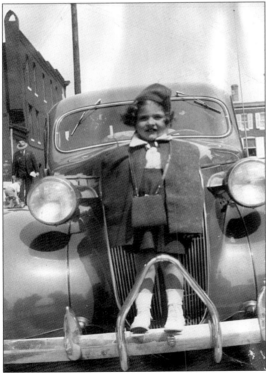

Automobiles (and hood ornaments) have changed dramatically over the past 65 years. Actually that is little Marlene Terzigni in the early 1940s on the front bumper of her dad's car parked (hopefully) on South Fagley Street. (Courtesy Marlene Donohue.)

The men of Our Lady of Pompei Church worked hard in the kitchen during social events, but it wasn't without its rewards. Bonding in this shot from around 1950 are, from left to right, a Mr. Ercole, Emilio Terzigni, Alfred Maggitti, and Albert Maggitti. (Courtesy Marlene Donohue.)

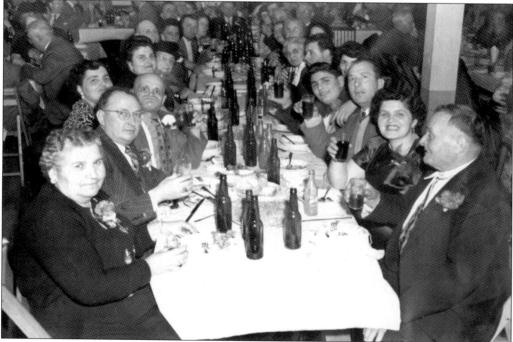

Pompei's banquet hall was at Pratt and Dean Streets. It's filled to capacity, and these folks are clearly enjoying themselves back in 1956. (Courtesy Marlene Donohue.)

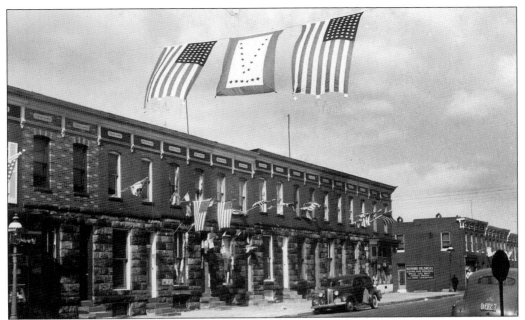

This is Clinton Street between Foster Avenue and Fleet Street in 1945, decorated in celebration of the end of World War II. Patriotism has never been in short supply in Highlandtown. (Courtesy Carol Doroff.)

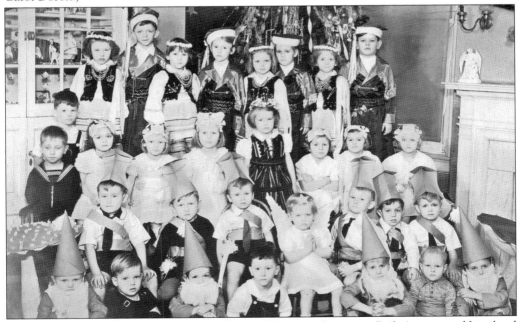

Polish nuns operated the Sister Servants of Mary Nursery at Patterson Park Avenue and Lombard Street. In this photograph from around 1937, the kids are dressed in costume for a holiday play. Carroll Skurzynski (1934–2002) is seated at the left in the second row. When he grew up, he became a professional musician, songwriter, and arranger, using the professional name Carroll Skinner. (Courtesy Patricia Skurzynski.)

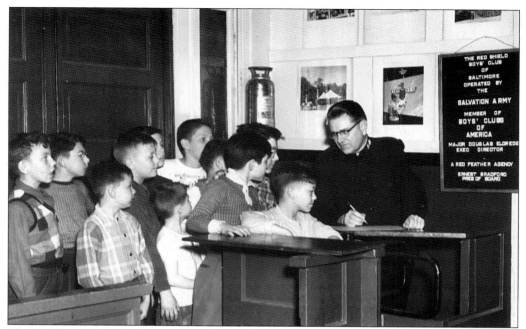

The Red Shield Boys Club on Clinton Street was responsible for saving the lives of countless boys for nearly 60 years by providing supervised sports and other activities. Maj. Douglas Eldridge was in charge of the Highlandtown club when this photograph was taken in the late 1940s or early 1950s. Declining enrollment forced the club to close in 2006. (Courtesy Calvin Gundlach Jr.)

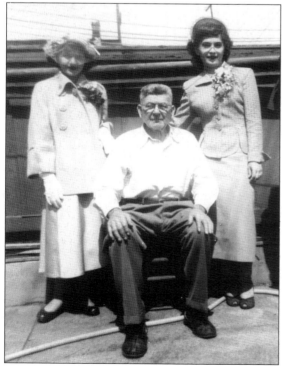

Genevieve Marshall (left) and Elizabeth Helton (the author's mother) flank their grandfather, Christian Markwood (1876–1955), in the backyard of his home on South Bouldin Street in the spring of 1953. A long-surviving family story held that Markwood came to America as an eight-year-old boy, having stowed away on a ship that sailed from Bremen, Germany. (From the author's collection.)

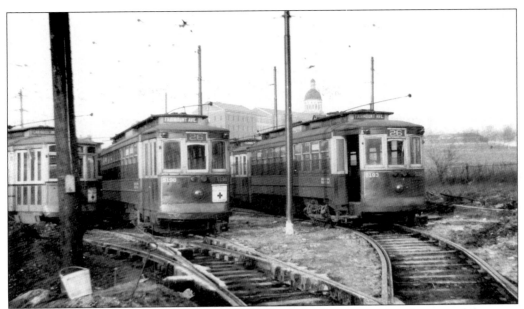

Taken in the 1920s or 1930s, these streetcars wait silently for their next run in the car yard that once existed near White Swan Park, at Ponca Street and Eastern Avenue. (Courtesy the Maryland Rail Heritage Library of the Baltimore Streetcar Museum, Inc./Baltimore Chapter NRHS, Inc.)

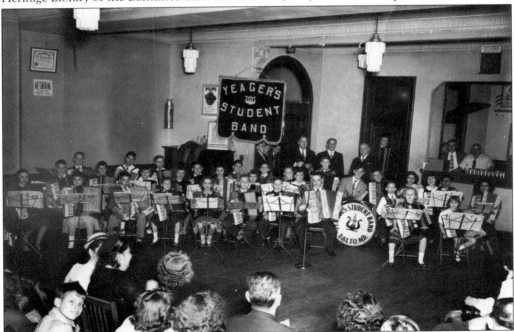

Yeager's Student Band often performed at the Knights of Columbus Hall as well as other clubs and churches. This photograph is from around 1948. Florence and Stanley (Stash) Sdanowich, who celebrated their 50th wedding anniversary in 2006, met as children when both were members of the band. They are in this photograph, seated in front of the Yeager's banner; (Stash is the boy to the left). (Courtesy Florence and Stanley Sdanowich.)

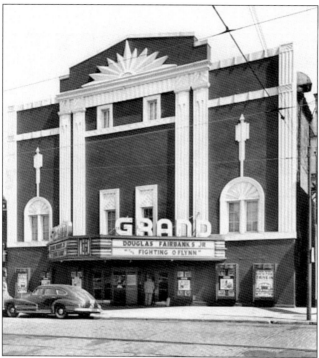

This is the Grand Theatre at 511 South Conkling Street as it appeared in 1949. Opened in 1914, it once sported a huge vertical sign similar to the one that adorned the old State Theatre on Monument Street. (Courtesy Ed Dobbins.)

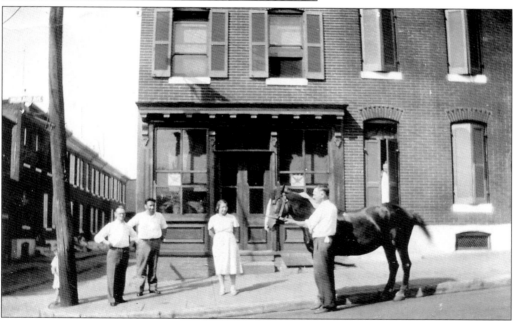

Shorty the horse made deliveries for Faulstich's Bakery at 706 South Highland Avenue. Family members say he was so smart, he knew the delivery route and stopped in front of the right houses, on the right days of the week, all by himself. With Shorty at the bakery were, from left to right, Christian Faulstich, John "Smitty" Schmidt, Rita Faulstich, and Nicholas Faulstich. The photograph is from the early 1930s. (Courtesy M. Rita Hubbel.)

This unidentified trio was either pitching pennies or, more likely, shooting dice on South Bouldin Street when someone with a camera came along in the 1940s. (Courtesy Betty Lane.)

Shopkeepers once took great pains to create attractive window displays. That was nowhere more evident than at Miller's Hardware in the 3300 block of East Baltimore Street. In 1944, Frances (Fritz) Shenk thought it and she would make for an appealing photograph. Partially visible in the background is the marquee of the old Aldine Theatre. Called the Pictorial when it opened in 1914, the Aldine closed in 1951. (Courtesy Frances Kitz.)

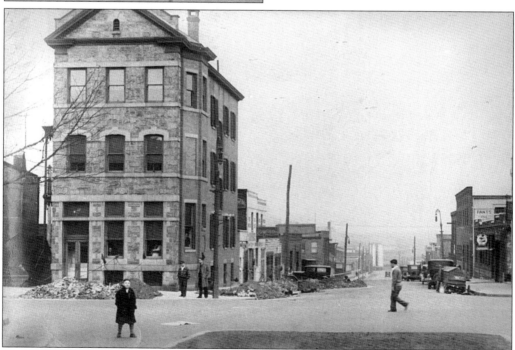

This time the camera faces east on Bank Street at Conkling Street in the 1920s. The debris piles were most likely the result of sewer connection activity. (Courtesy Mike Wehrman.)

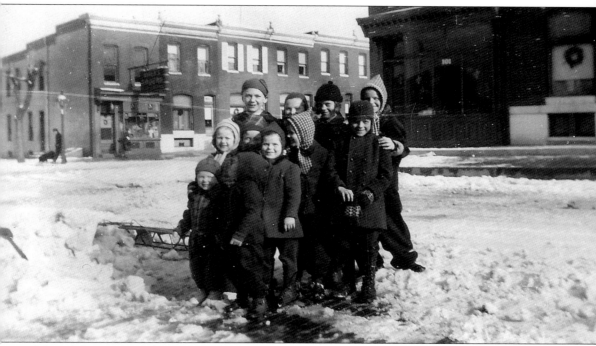

Though Patterson Park was just a few blocks to the west, these youngsters found sledding in the street to be just as good. It's the early 1940s, and in the background to the left is Kiker's Bar at Bouldin and Lombard Streets. Mr. Kiker was a hunter who offered neighborhood residents free beer and hot dogs whenever he shot a deer. (Courtesy Betty Lane.)

Carolyn Newman Schultz was a first generation American. In the early 1940s, she poses with her newborn grandson Christopher (Christy) Newman behind the family home in the 3200 block of East Baltimore Street. (Courtesy Mary Jane Tuma.)

This odd-looking vehicle is an electric bus, or trackless trolley. It uses pivoting catenary poles that carry electricity from overhead wires, like streetcars. Yet with rubber tires, it needed no tracks, and thanks to the pivoting mechanism on the roof, it could pick up and discharge passengers curbside instead of in the middle of a street. The Baltimore Transit Company converted the Number 10 line on Eastern Avenue from streetcars to trackless trolleys in the 1930s, much to the delight of motorists. (Courtesy Marion Zych.)

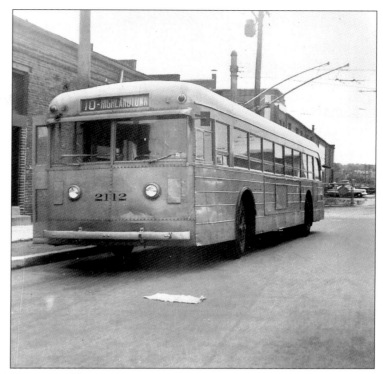

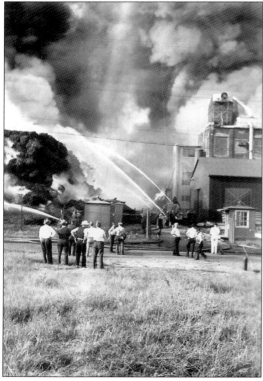

John Rockstroh and his friends were playing baseball near Haven and O'Donnell Streets in September 1940 when they saw a small fire burning atop Crown Cork and Seal. They sounded the alarm, and firefighters quickly extinguished the flames—so they thought. Once they left, the fire reignited, setting ablaze stockpiles of cork that burned for days. (Courtesy John Rockstroh.)

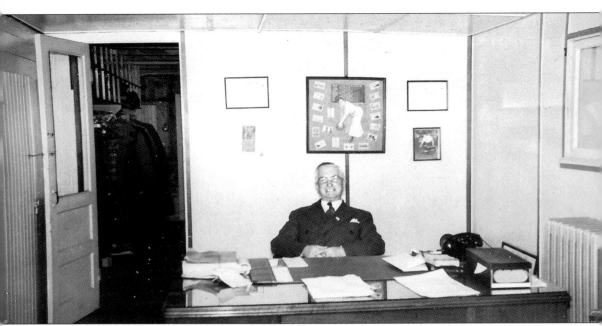

Jimmie Marks was a beloved businessman who, in November 1936, opened the New Highland Bowling Center, a 30-lane duckpin house at 3801 Fleet Street. Previously he had run a smaller duckpin center a few blocks away on Conkling Street, and also had lanes in Dundalk. He is seen here in his office at the New Highland Lanes in the 1930s or 1940s. Jimmie Marks died in 1956. (Courtesy June Bocek.)

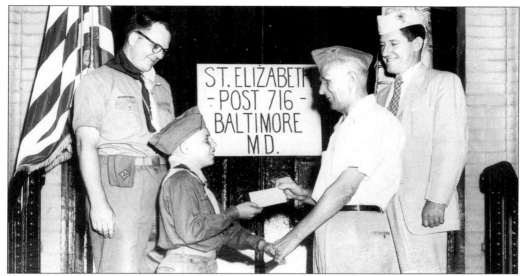

In July 1953, St. Elizabeth Catholic War Veterans Post 716 made a contribution to the Boy Scouts of America, Troop 34, for the Scouts' Broad Creek Memorial Camp Fund. From left to right are Scoutmaster Martin Schultz, Boy Scout Second Class Walter Nowak, Post 716 commander Joseph Blume, and Post 716 post commander Tom Nooft. (Courtesy Jean Jomidad.)

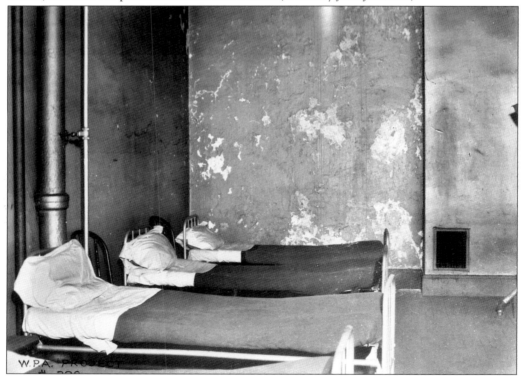

Bay View Asylum on Eastern Avenue became Baltimore City Hospitals in 1926. In 1935, a WPA project was created to provide repairs and improvements at the facility. By the look of this ward, those repairs and improvements were badly needed. (Courtesy Enoch Pratt Free Library.)

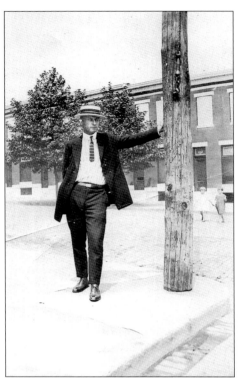

Normally behind the camera, John Rockstroh (1904–1949) poses on this occasion at Hudson and Seventh (Grundy) Streets in the 1920s. He worked for Esso at the time, but found things there less than secure or safe. Eventually he joined the Baltimore Police Department, where at least there was job security. (Courtesy John Rockstroh.)

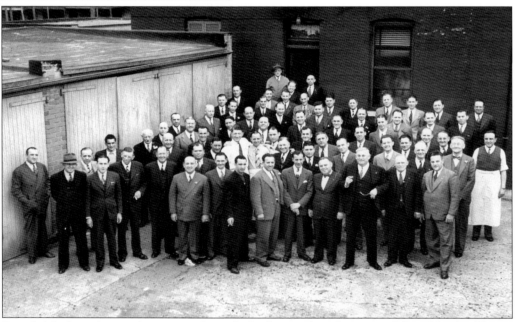

Social clubs brought together men with similar backgrounds and interests. Many, like the Clipper Club at 621 South Dean Street, started out as political clubs. On April 18, 1943, Clipper Club members gathered for a mortgage-burning ceremony, then posed for this photograph afterward. (Courtesy Calvin Gundlach Jr.)

Carol Sealover is all dressed up as a nurse in her Foster Avenue backyard in 1945. Note the flowerpots made from discarded cookwear. Highlandtowners have never been short on creativity. (Courtesy Carol Doroff.)

Here is an aerial shot of Baltimore City Hospitals taken in 1933. The building with the water tower (left background) is the tuberculosis wing. Below that is the chronic hospital Ward A with its wing. To the right is the general hospital, erected in 1932, below which is the nurses' home, also completed in 1932. To the far right is the tuberculosis ward for African Americans patients. The old city firehouse is visible toward the bottom, along with Anglesea and Bonsal Streets to the right. (Courtesy Enoch Pratt Free Library and the 104th Photo Section, 29th Division Aviation, Maryland National Guard.)

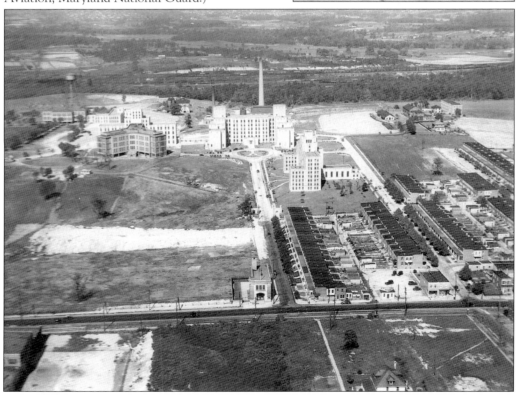

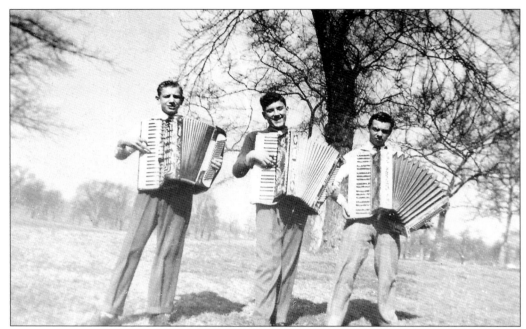

They called themselves "The Merry Musketeers," and on this mild winter day in 1950 or 1951, they serenaded the squirrels in Patterson Park. From left to right are Leonard Weber, Stanley Sdanowich, and Teddy Zack. (Courtesy Florence and Stanley Sdanowich.)

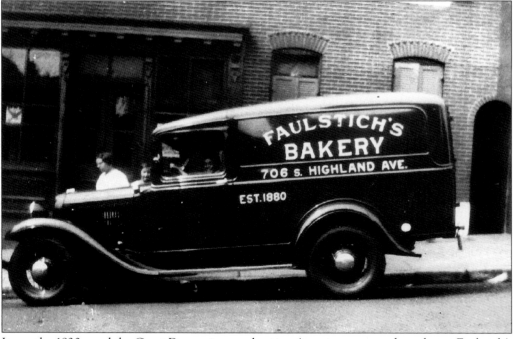

It was the 1930s, and the Great Depression was hurting Americans everywhere, but at Faulstich's Bakery at 706 South Highland Avenue, business was good—so good in fact that they retired Shorty, the delivery horse, and bought this truck. (Courtesy M. Rita Hubbel.)

In this shot from the 1930s, Luigi DiPasquale Sr. takes a break on the steps of his grocery store at 3700 Claremont Street. He is wearing a hat from the Pompei Church Band, a group he helped organize. His friend Mr. Cironne is seated at the left. (Courtesy Angie Knox.)

In the first half of the 20th century, there were four duckpin centers within a mile of each other, not to mention lanes nearby on Monument Street. Almost every Highlandtown church had a team. St. Elizabeth's bowlers were Neal Schultz (with the ball), and, from left to right in the background, Margy Voith, Ralph Schultz, William Haggerty (a member of the church for more than 70 years), and Vernon Schultz. The St. Elizabeth team bowled at the Spillway on Monument Street and Milton Avenue, where this photograph was taken September 13, 1949. (Courtesy Jean Jomidad.)

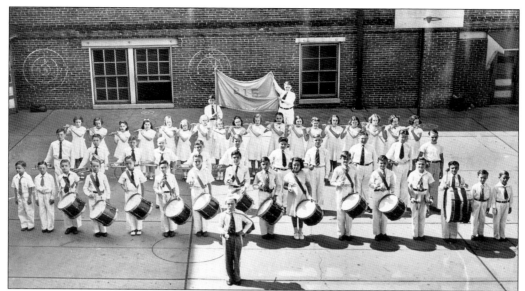

School 215's Drum and Bugle Corps stop marching long enough to have this picture taken in 1941. Mrs. Gilbert (not shown) was the teacher in charge. The drum major front and center is Eugene Schuyler. Bill Miller (first row, third from the left) still has his Montgomery Ward field drum. (Courtesy Bill Miller.)

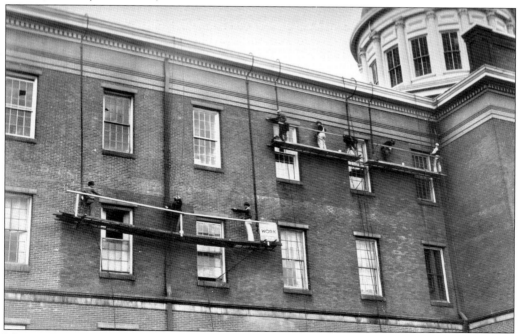

The Works Progress Administration (later Works Projects Administration), or WPA, was created in May 1935 as a "make work" program that provided government-funded jobs to the unemployed during the Great Depression. WPA project number 323 called for repair and improvements to buildings at Baltimore City Hospitals. This 1935 photograph shows workers painting up the exterior brick work. (Courtesy the Barker Collection, Enoch Pratt Free Library.)

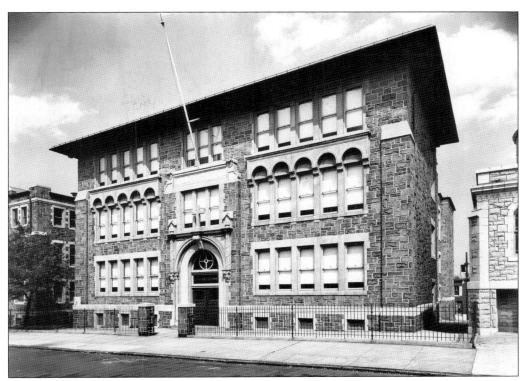

Viewed from its entrance on Lakewood Avenue, this is St. Elizabeth Catholic School around 1945. Built in the 1920s, today it is Patterson Park Public Charter School. (Courtesy Jean Jomidad.)

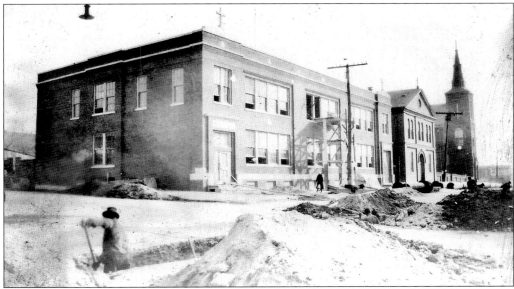

Meanwhile, sewer installation work was captured by the camera in front of Sacred Heart of Jesus School on Highland Avenue between Fleet Street and Foster Avenue. The original sanctuary is visible at the right in this 1920s photograph. Sacred Heart was built on the former site of Fort Marshall. (Courtesy John Rockstroh.)

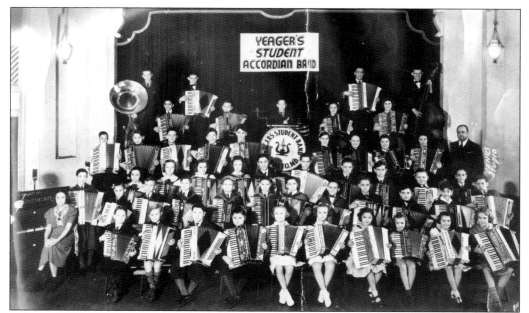

Yeager's Student Accordian Band attracted youngsters from all over Highlandtown—not surprising considering the large numbers of German and Polish families in the area. What's a polka without an accordian? This photograph was taken in the 1930s at the former Knights of Columbus hall on Highland Avenue. (Courtesy Southeast Community Development Corporation.)

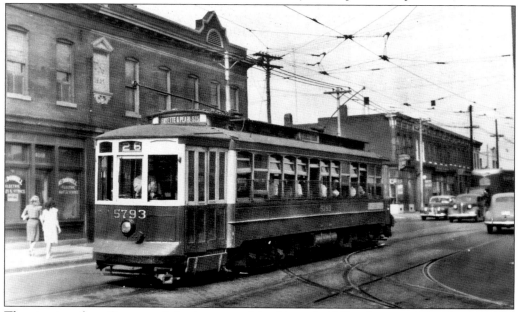

The streetcar from Sparrows Point is captured in this early 1940s photograph heading west on Lombard Street, just past Haven. The tracks in the foreground lead to the streetcar barn on Grundy Street. Except for the car barn's conversion into senior housing, little has changed at this site in more than half a century. (Courtesy the Maryland Rail Heritage Library of the Baltimore Streetcar Museum, Inc./Baltimore Chapter NRHS, Inc.)

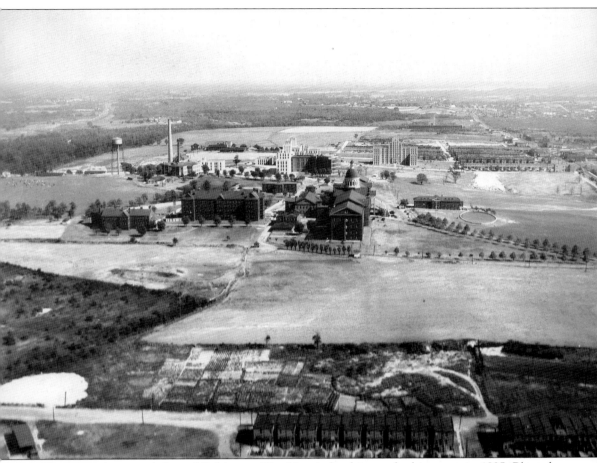

Here's another aerial shot of Baltimore City Hospitals, this one looking east in 1935. Blessed with plenty of real estate, the hospital had its own working dairy. Those specks at the far left are cows. At the center just beyond the buildings is the area that would become Patterson High School, Our Lady of Fatima church and school, Joseph Lee Field, and the Bayview neighborhood. Anglesea and Bonsal Streets are already there, at the right. White Swan Park is barely visible at the lower left. (Courtesy 104th Photo Section, 29th Division Aviation, Maryland National Guard/Enoch Pratt Free Library.)

Three generations of the Smith and Newman families crowd onto the white marble steps of this East Baltimore Street home in the 1940s. (Courtesy Mary Jane Tuma.)

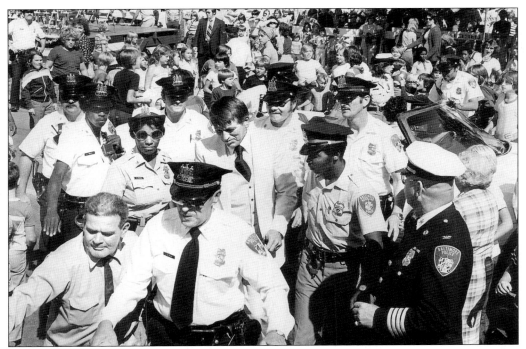

Former Baltimore Colts quarterback Johnny Unitas was so beloved that nearly a dozen police officers were needed to escort him from a car to the reviewing stand during the "I Am An American Day" parade in the 1970s. A local icon, his sudden death on September 11, 2002, is still mourned by his legion of fans. (Courtesy Tony DiPietro.)

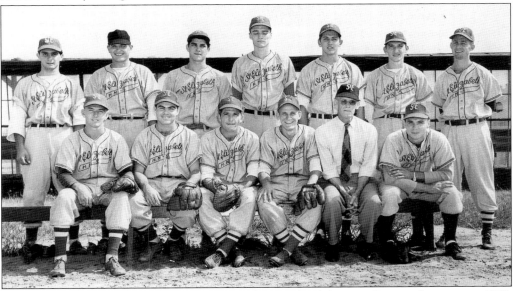

The St. Elizabeth Unlimited Baseball team was the Maryland Amateur League champion in 1950. Pictured are, from left to right, (first row) Joe Lingerman, Bob Klein, Bob Schaefer, Rich Bernard, manager John Doyle, and Frank Hlavac; (second row) Mike Piccarelli, Lou Hofferbert, Lou Roper, Charlie Mack, Pat Vito, Frank Csyzechowicz, and Johnny Grund. (Courtesy Jean Jomidad.)

Looking proud as a peacock with his foot resting on the running board of a new 1939 Buick is Louis DiPasquale Jr. at the corner of Claremont and Conkling Streets. (Courtesy Angie Knox.)

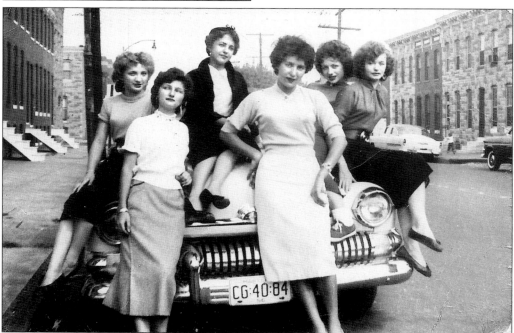

Carol Sealover was all grown up when she and several friends posed on the hood of this car on Hudson Street, between East Avenue and Bouldin Street in 1956. Carol is on the far right. (Courtesy Carol Doroff.)

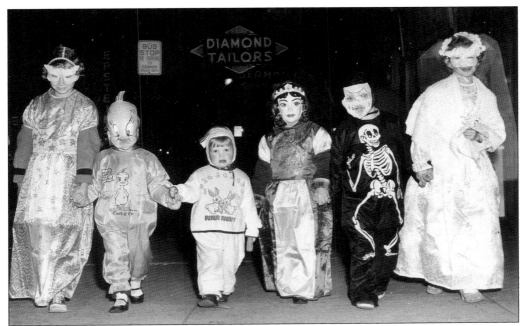

This was Halloween on the Avenue, 1957 style. From left to right, the trick-or-treaters are Elizabeth Schmidt, Michael Schmidt, Deborah Malashuk, Sharon Schmidt, Kathleen Malashuk, and Patricia (Pam) Malashuk. (Courtesy Carol Doroff.)

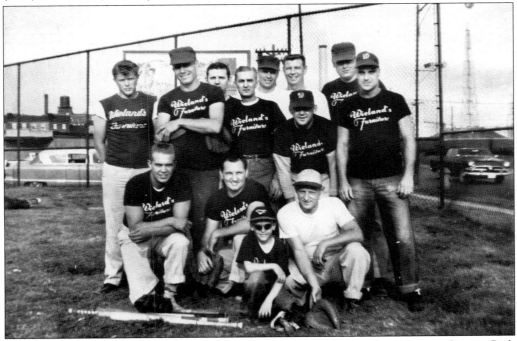

For years, Wieland's Furniture had its own softball team, which played its games in Canton Park off Boston Street. Calvin Gundlach Sr. is at the far right. The other players are unidentified. (Courtesy Calvin Gundlach Jr.)

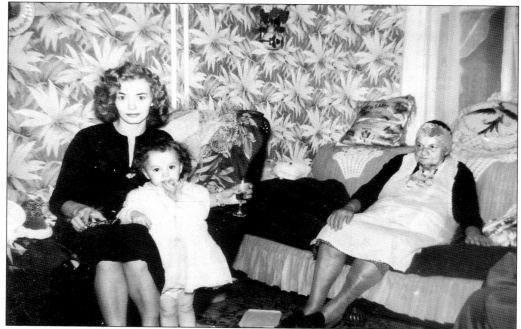

Carol Sealover and daughter Shelley joined Carol's grandmother, Katherine Warga, in the living room of their South Ellwood Avenue home in the late 1950s. Katherine was a native of Gdansk, Poland. (Courtesy Carol Doroff.)

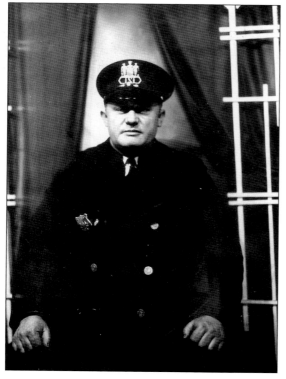

John Rockstroh sat for this formal shot in his Baltimore Police uniform in the 1930s or 1940s. His patrol area included some of the city's meanest streets, which may have contributed to his death in 1949 at age 45. No, your eyes aren't deceiving you—the photograph was printed backward! (Courtesy John Rockstroh.)

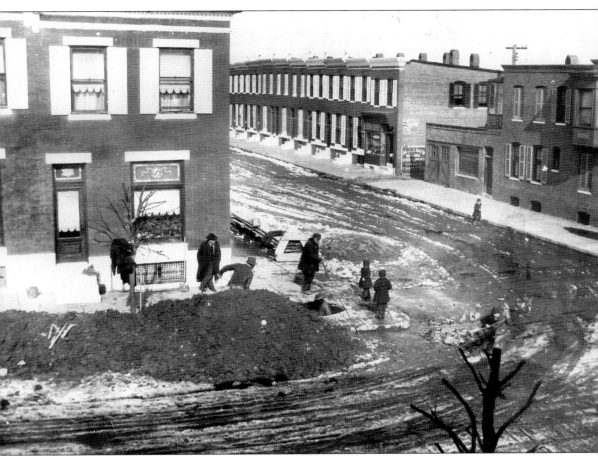

Sewer hookups were done largely with manual labor, which continued despite harsh winter weather. This shot from the 1920s was taken at Hudson and Dean Streets. (Courtesy John Rockstroh.)

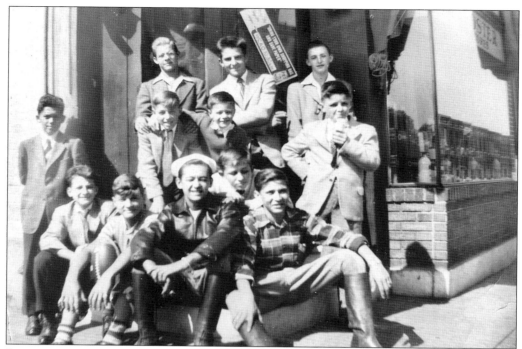

Foster's Corner, at Pratt and Bouldin Streets, got its name from Foster's Grocery Store. A dozen boys gathered on the steps of the store for this photograph taken in the late 1930s or early 1940s. (Courtesy Betty Lane.)

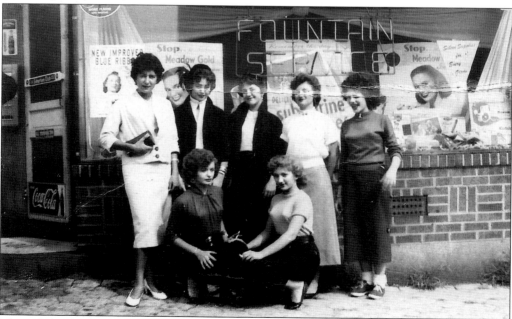

Meanwhile, the ladies gather in front of Ben's at East Avenue and Hudson Street around 1956. Many of Highlandtown's corner grocers, barbershops, and confectionaries have long since been converted into private homes. (Courtesy Carol Doroff.)

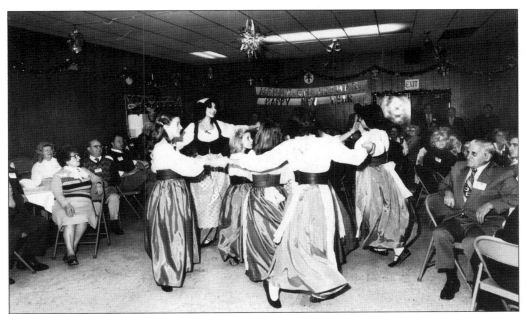

During a 1978 Christmas party, these young ladies dance to Italian songs at the Sons of Italy lodge on Gough Street. The tall girl second from the left is Felicia Zannino-Baker. (Courtesy Felicia Zannino-Baker.)

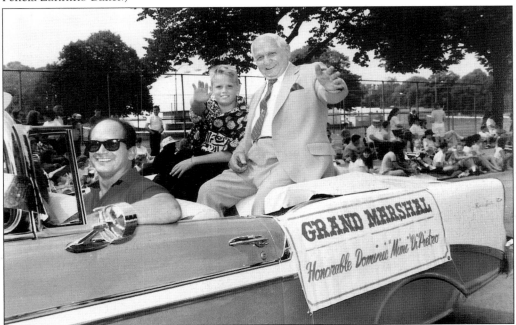

For years, Highlandtown's unofficial "mayor" was Baltimore City councilman Dominic "Mimi" DiPietro. He is photographed here serving as grand marshal for one of the final "I Am An American Day" parades. A powerful politician, he was also one of Baltimore's more colorful characters. Asked once to comment on the virtues of the city, he replied, "We ain't got no volcanoes here." (Courtesy Tony DiPietro.)

GRAND *theatre*

511 South Conkling Street
Open Daily 1:30 Including Sunday
Phone 276-6446

NOW PLAYING

**ELSA THE LIONESS
WAS BORN FREE...
NOW HER CUBS
ARE LIVING FREE!**

COLUMBIA PICTURES and CARL FOREMAN PRESENT

LIVING FREE

by JOY ADAMSON

An Open Road/Highroad Production G

Starts WEDNESDAY! **JUNE 21**

The West the way it really was!

CLIFF ROBERTSON in

"THE GREAT NORTHFIELD, MINNESOTA RAID"

A UNIVERSAL / ROBERTSON AND ASSOCIATES PRODUCTION · TECHNICOLOR® PG

"THE GREAT NORTHFIELD, MINNESOTA RAID"

CO STARRING **ROBERT DUVALL**

Written and Directed by PHILIP KAUFMAN · A JENNINGS LANG PRESENTATION

A UNIVERSAL / ROBERTSON AND ASSOCIATES PRODUCTION · TECHNICOLOR® PG **PARENTAL GUIDANCE SUGGESTED** SOME MATERIAL MAY NOT BE SUITABLE FOR PRE-TEENAGERS

H

Fe

DI 2-

3200 EAST

TTERSON *theatre*

Eastern & East Avenues
Enjoy Rocking Chair Comfort
Relax-Recliner Chairs
Phone: 675-0943

N-MON-TUES JUNE 18-19-20

if you like
ping suspense
surprise endings...

e Groundstar
Conspiracy"

al / Hal Roach International Production
OLOR* PANAVISION* **PG**

1:45, 3:45, 5:45,

7:45 and 9:45 P.M.

WEDNESDAY thru TUESDAY
NE 21-22-23-24-25-26-27

**"IT COULD BE THE MOST TERRIFYING
MOTION PICTURE I
HAVE EVER MADE!"**
—ALFRED HITCHCOCK

RENZY

5, 3:45, 5:45, 7:45 and 9:45

HLAND

al **SAVINGS AND LOAN**
ASSOCIATION

NVENIENT LOCATIONS

0
VE.

488-6500

FRANKFORD PLAZA
SHOPPING CENTER

INSURED

● INSURED SAVINGS
● HIGH DIVIDENDS
● MORTGAGE LOANS—
 ALL PLANS
● UTILITY BILLS
● MONEY ORDERS
● EVENING HOURS

*Aye·tis the thrifty
place to Save!*

Durkee Enterprises, which owned the Grand and Patterson, also owned Arcade Press, which for years printed fliers promoting theater attractions. This one was from the week of June 18, 1972. Listings for all the Durkee theaters (11 at that time) were printed on the reverse side. By the summer of 2006, Durkee's holdings consisted only of a flea market at the site of their old North Point Drive-In theater in Dundalk.

119

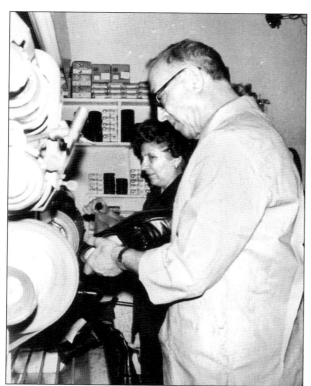

Chester Canestraro (1914–1988) was born in Fontechiari, Italy, but came to the United States in 1929. After serving in World War II, he opened Chester's Shoe Service in 1945 at 406 South Highland Avenue. Over the years, he sponsored many other Italian immigrants, helping them find jobs and places to live and loaning them money. (Courtesy Linda Janzik.)

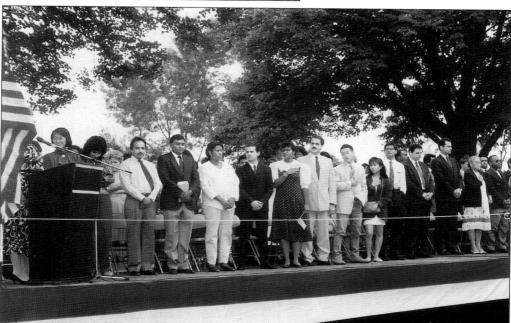

New citizens, some clutching miniature American flags, prepare for the Pledge of Allegiance from a podium at one of the last "I Am An American Day" parades in the 1990s. (Courtesy Tony DiPietro.)

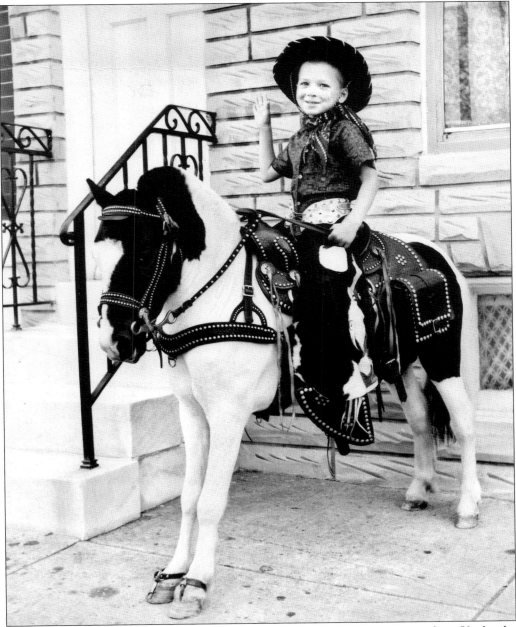

Only the luckiest of Highlandtown kids got a pony ride, since they cost as much as 50¢ by the middle of the 20th century. Ronnie Warga of Foster Avenue was one such fortune youngster around 1950. (Courtesy Carol Doroff.)

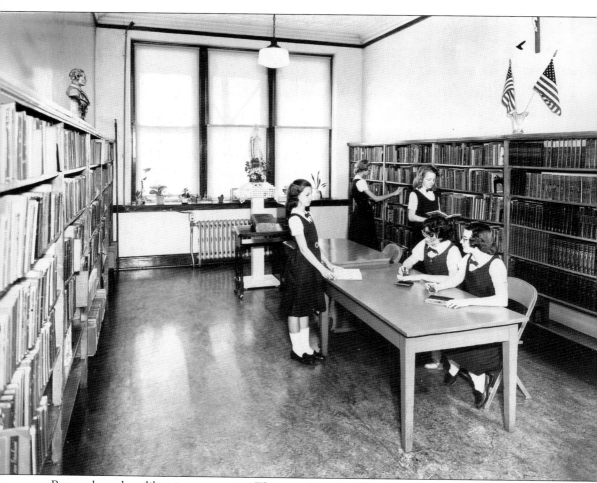

Remember when libraries were quiet? This was the school library at St. Elizabeth in June, 1961. (Courtesy Jean Jomidad.)

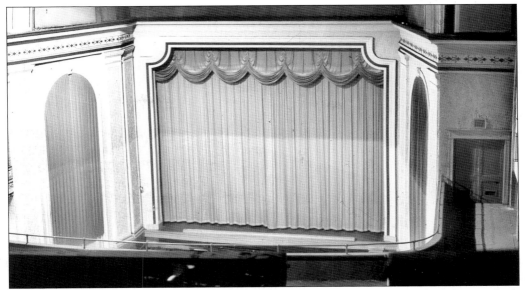

This 1976 interior shot of the Grand Theatre is rare, in that it was taken from the balcony, which had been closed to the public since the 1950s or 1960s. As an usher from 1971 to 1973, the author earned the princely sum of $1.10 per hour. Carroll Fuller was the Grand's projectionist at that time. A Durkee Enterprises employee since the 1920s, he told wonderful stories about working with the likes of Red Skelton and Abbott and Costello in vaudeville at the State Theatre on Monument Street. (Courtesy Ed Dobbins.)

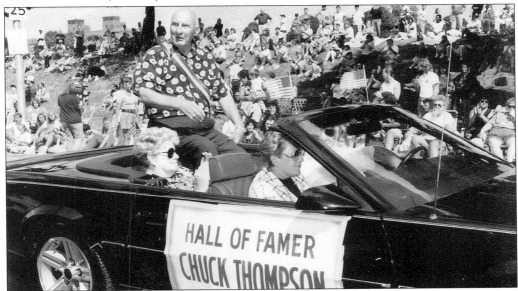

Baseball Hall of Fame broadcaster Chuck Thompson (1921–2005) appeared in one of the final "I Am An American Day" parades in the mid-1990s. The voice of both the Baltimore Orioles and Colts for a generation, Thompson also hosted a jazz music show on WITH-AM in the 1950s, and voiced hundred of local radio and television commercials. A peerless professional, he was as beloved as the athletes whose feats he described, often with trademark expressions like "Go to war, Miss Agnes," or "Ain't the beer cold!" (Courtesy Tony DiPietro.)

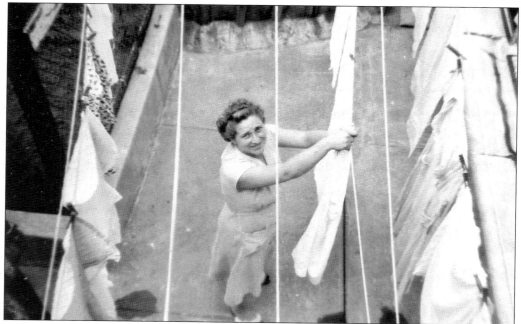

In this narrow yard on South Highland Avenue, Yolanda Canestraro hung her wash out to dry back in the 1950s or 1960s. If you were modest, there was an art to hanging out clothes. Large items like sheets and towels went on the outer lines, while underwear, stockings, and the like hung between them on the inner lines. (Courtesy Linda Janzik.)

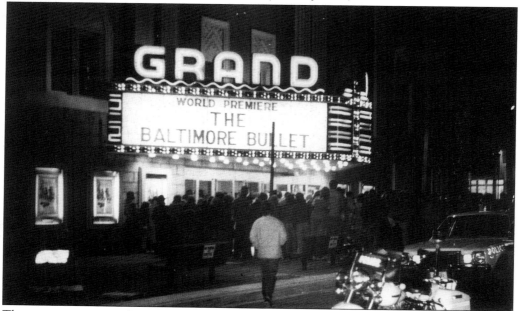

The stars were out on this winter night in 1980, when the Grand hosted the world premiere of *The Baltimore Bullet*. Havre de Grace native Ed Bakey appeared in the film in a supporting role as "Skinney." Baby boomers may remember Bakey as kid's show host "Pop-Pop" on Channel 13 in the 1950s. (Courtesy Felicia Zannino-Baker.)

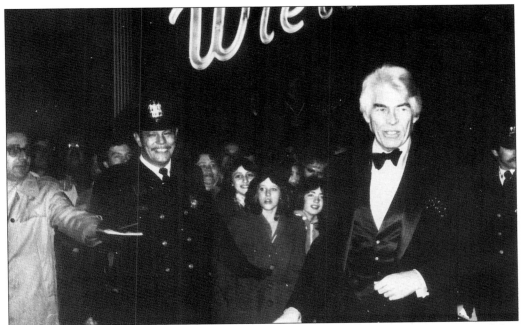

Police had to shut down the 500 block of South Conkling Street to accommodate the crowd that showed up for the premiere of *The Baltimore Bullet*. Actor James Coburn is shown here exiting his limousine in front of Wieland's Furniture store en route to the Grand across the street. (Courtesy Felicia Zannino-Baker.)

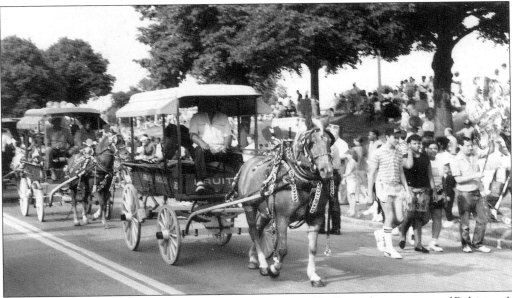

Bringing up the rear each year in the "I Am An American Day" parade were many of Baltimore's street merchants or hucksters. Known locally as "Arabs" (pronounced A-rabs), their colorful wagons usually carried fresh fruits and vegetables throughout the city. Horses drawing the wagons were often decorated with hats or feathers and adorned with rings and bells to attract attention. Only a handful of street Arabs remain in business as of 2006. (Courtesy Tony DiPietro.)

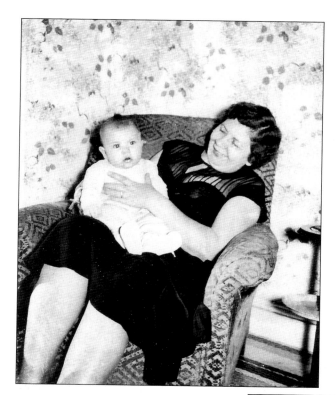

Anna Markwood Hulseman (1905–1999) was born in Fells Point but moved to Bouldin Street at six months of age. In this 1955 photograph, she has her great nephew (the author) on her lap. Her house at 917 South Bouldin Street was the author's second home, and she was his surrogate mother.

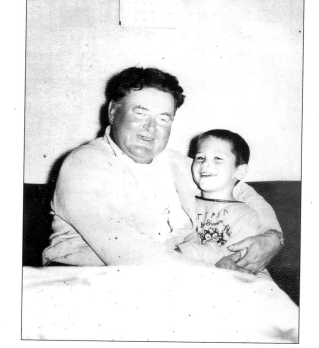

Frank Hulseman (1902–1967) was a carpenter by trade who enjoyed photography, dogs, day trips to Beverly Beach, and making people laugh. Photographed here with the author around 1959, he owned Buicks, smoked cigars, and called everyone "Butch."

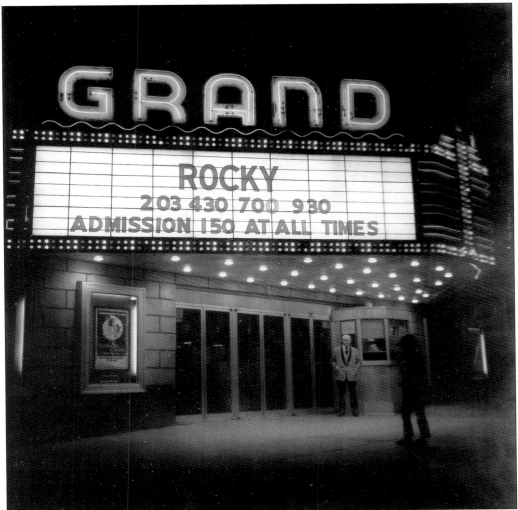

In 1976, the name on the Grand's marquee described both its feature and its future. When the venerable old neighborhood theater could compete no more, its doors were shuttered for good on October 24, 1985. Except for an aborted attempt to make it a banquet hall, the Grand sat vacant for the next 19 years and was left to slowly decay. The theater was demolished in January 2004. (Courtesy David Nolte.)

ACROSS AMERICA, PEOPLE ARE DISCOVERING SOMETHING WONDERFUL. *THEIR HERITAGE.*

Arcadia Publishing is the leading local history publisher in the United States. With more than 3,000 titles in print and hundreds of new titles released every year, Arcadia has extensive specialized experience chronicling the history of communities and celebrating America's hidden stories, bringing to life the people, places, and events from the past. To discover the history of other communities across the nation, please visit:

www.arcadiapublishing.com

Customized search tools allow you to find regional history books about the town where you grew up, the cities where your friends and family live, the town where your parents met, or even that retirement spot you've been dreaming about.